Greek Gold
from
Hellenistic Egypt

THE GREAT SPHINX, PYRAMIDS OF GEZEEH
January 17, 1839 (detail).

David Roberts (Scottish, 1796–1864)
Lithograph by Louis Haghe (Belgian, 1806–1885)

Greek Gold
from
Hellenistic Egypt

Michael Pfrommer
with Elana Towne Markus

GETTY MUSEUM STUDIES ON ART

Los Angeles

© 2001 The J. Paul Getty Trust

Getty Publications
1200 Getty Center Drive
Suite 500
Los Angeles, California 90049-1682

www.getty.edu

Christopher Hudson, *Publisher*
Mark Greenberg, *Editor in Chief*

Project Staff
Louise D. Barber, *Manuscript Editor*
Mary Louise Hart, *Curatorial Coordinator*
Benedicte Gilman, *Editorial Coordinator*
Elizabeth Burke Kahn, *Production Coordinator*
Jeffrey Cohen, *Designer*
Ellen Rosenbery, *Photographer*
 (Getty Museum objects)
David Fuller, *Cartographer*

All works are reproduced (and photographs
provided) by courtesy of the owners, unless
otherwise indicated.

Typography by G & S Typesetters, Inc.,
 Austin, Texas
Printed in Hong Kong by Imago

CONTENTS

VII Foreword, *Marion True*

X Map

XII Chronology

XIV Introduction

1 The Jewelry

9 Alexander the Great: A New God in Egypt

15 Alexandria, a New City in an Old World

28 The God of Love as King of Egypt

33 Powerful Queens: From Arsinoë II to Kleopatra VII

46 Religion: One Language for Two Civilizations

59 At the Brink of Disaster:
The Golden Treasure in Its Historical Perspective

65 Bibliography

70 Ptolemaic Dynasty

74 Acknowledgments

Final page folds out, providing a reference color plate of the jewelry

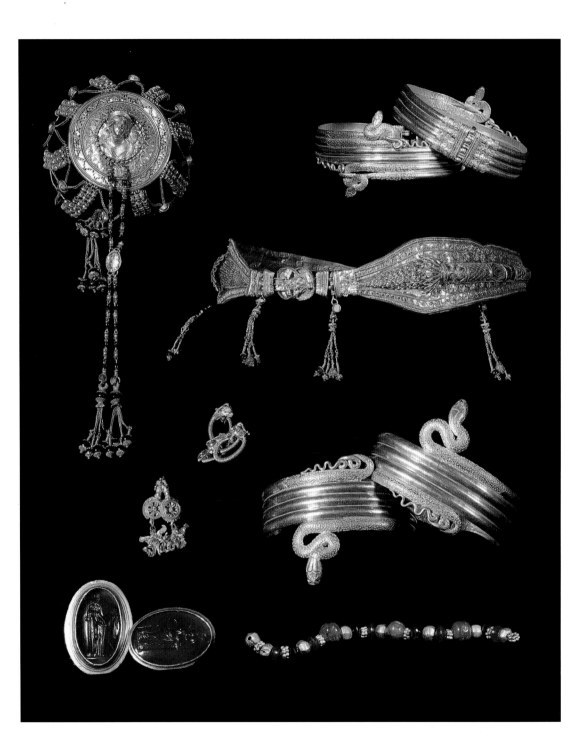

FOREWORD

MARION TRUE

Few evenings stand out in memory as clearly as the one on which I first confronted the great collection of Hellenistic gold jewelry presented in this publication [FIGURE 1]. Visiting New York together with my friend and colleague Arielle Kozloff, then Curator of Ancient Art at the Cleveland Museum of Art, we had been invited to dinner at the home of collectors Lawrence and Barbara Fleischman. Dinner was to be followed by a special treat. As we seated ourselves in the library, Larry produced a small, brown paper bag. From the crumpled sack he lifted out one tissue-wrapped object after another and laid them on the table, then slowly he began to unwrap each piece. First came the magnificent hairnet mounted on a cushion of rose-colored satin, its long tassel in situ but its smaller one unattached beside it. Next emerged the two bracelets of intertwined snakes, followed by the larger, heavier pair of armlets, each formed by a single coiled serpent. The fragile stephane (diadem) required the most patience, and we held our collective breath as its exquisitely decorated surface was slowly revealed. Damaged and repaired already in antiquity, it must have been worn thin by its proud owner. Carefully, we set it aside so that we could admire the two large finger rings, one decorated with an image of Artemis, the other with an image of Tyche. As I slipped one ring on, Larry cautioned that I might have to part with my finger if the ring got stuck. By the time we got to the Erote earrings and the string of colorful beads, we were almost too overwhelmed to notice them.

One of the most intriguing aspects of antiquities is the glimpse they provide us into past lives. The Fleischmans had always been drawn to antiquities in particular because of their very human associations, and this collection of

Figure 1
Assemblage of
Ptolemaic jewelry.
Late third–early
second century B.C.
Gold, with gems, pearls,
possibly shell, and
glass-paste inlays.
Malibu, J. Paul Getty
Museum (92.AM.8).

jewelry had a very personal appeal. All the pieces, Larry told us, were said to have been found together, possibly in a grave. Thus, the parure had once belonged to a woman who, at least according to the traces on the pieces themselves, had worn them often, surely with pleasure. Talking together about the magnificence of the whole ensemble, we had no difficulty conjuring up the image of a Mediterranean beauty, her dark hair pulled back into a chignon held in place by the hairnet, wearing the tasseled stephane around her temples and the snakes around her wrists and arms. Larry speculated upon the gleaming appearance of the gold as the woman moved through rooms lighted by oil lamps.

For a curator, perhaps the most difficult emotion to deal with gracefully is envy. Building a collection requires a healthy sense of competition and a willingness to be aggressive in pursuit of the great work of art. It is always a bad moment when you see something you want for your collection, only to find out that it has already been bought. It is a worse moment when you find out that it has already been bought by dear friends, even if they are also your best competitors! Trying to disguise our baser feelings with hypocritical smiles, Arielle and I congratulated the rightfully proud new owners of the gold jewelry, assuring them that we were very happy for them to have acquired such an important collection. Larry was later to recall that he had never seen two less sincere performances.

With time, we all came to laugh about that infamous evening. Arielle and I accepted the missed opportunity with fatalistic humor, and the Hellenistic gold jewelry became one of the key displays in the Fleischmans' growing collection of ancient art. Some months later, Larry was to add more pieces to the collection—the string of tiny gold cowrie shells and the two pairs of antelope-head earrings, which the dealer claimed had originally been part of the group but had inadvertently become separated from the larger pieces.

Suddenly one morning, the Getty Museum's unexpected second chance came. Larry called to ask if we would be interested in acquiring the Hellenistic gold from him. He offered few details, but I knew that, given the importance of the assemblage, he and Barbara had begun to feel uncomfortable about its security and the appropriateness of having it in a private collection. Not wanting to risk losing it again, Getty Museum Director John Walsh and the Board of Trustees acted swiftly to acquire the jewelry for the Museum in 1993.

This splendid ensemble was exhibited to the public for the first time during the symposium on Alexandria and Alexandrianism held at the Getty Museum April 22–25, 1993. It was on this occasion that Michael Pfrommer, the author of this monograph, first saw the collection. His interest in the exquisite workmanship and his appreciation for the unusual imagery were so immediately apparent that we invited him to undertake the initial publication of this collection. The pieces later provided the focus of the jewelry gallery in the exhibition of the Fleischman collection, *A Passion for Antiquities*, which was shown in the Getty Villa in Malibu (October 1994–January 1995) and at the Cleveland Museum of Art (February–April 1995). When the jewelry returned to Malibu from Ohio, the ensemble remained on display in the Villa until the closure of that building for renovations in July 1997.

Many scholars have asked about the identification of the group as an ensemble. How reliable is the information that the objects were found together? Like all unsubstantiated statements that may accompany works of art of undocumented provenance, this allegation had to be taken with some skepticism. Though some objects, such as the bracelets or the finger rings, clearly seemed to form pairs, the group as a whole would not necessarily have suggested one source at first glance. In fact, the information from the vendor that this was a single ensemble would prove to be very valuable as a point of departure for the later scientific studies. The detailed technical study undertaken for the Fleischmans by Jack Ogden, a great English expert on ancient jewelry, and the analysis of the complex iconography provided by Michael Pfrommer, a leading German specialist in Hellenistic metalwork and ornamental patterns, generally support this thesis. Ogden's extensive report on the extraordinary technical features exhibited by the goldwork suggested the pieces were probably not made in the same workshop but that they were all of Hellenistic Egyptian workmanship. The evidence for this provenance was further strengthened by the images of female deities represented in gold and on the engraved gemstones; and these can all be most persuasively interpreted in relationship to one another, as Michael Pfrommer explains in depth in the following.

CURATOR OF ANTIQUITIES
The J. Paul Getty Museum

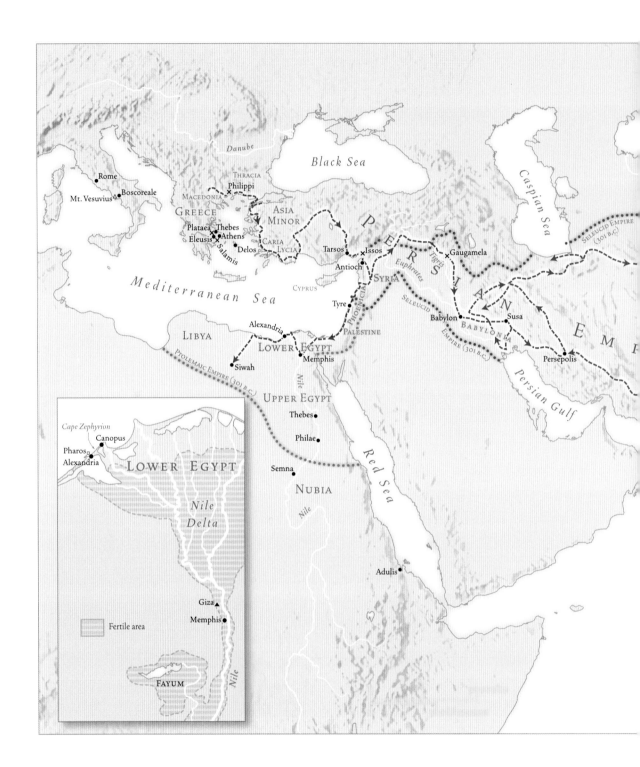

Danube

Black Sea

Caspian Sea

SELEUCID EMPIRE (301 B.C.)

Rome

THRACIA

Philippi ×

MACEDONIA

Mt. Vesuvius ▲ Boscoreale

GREECE

ASIA
MINOR

P E R S

Plataea Thebes
Eleusis Athens
 Salamis CARIA
 Delos LYCIA

Tarsos
 × Issos

Antioch

Gaugamela ×

SYRIA

Euphrates

Tigris

I
A

Mediterranean Sea

CYPRUS

Susa

N

Tyre

PHOENICIA

SELEUCID
EMPIRE (301 B.C.)

Babylon

BABYLONIA

E M P I

Alexandria

PALESTINE

LIBYA

LOWER EGYPT

Memphis

Persepolis

PTOLEMAIC EMPIRE (301 B.C.)

Siwah

Persian Gulf

Nile

UPPER EGYPT

Thebes

Philae

Red Sea

Semna

NUBIA

Nile

Adulis

Inset: Lower Egypt

Cape Zephyrion

Canopus

Pharos
Alexandria

LOWER EGYPT

Nile
Delta

Fertile area

Giza ▲

Memphis ●

FAYUM

Nile

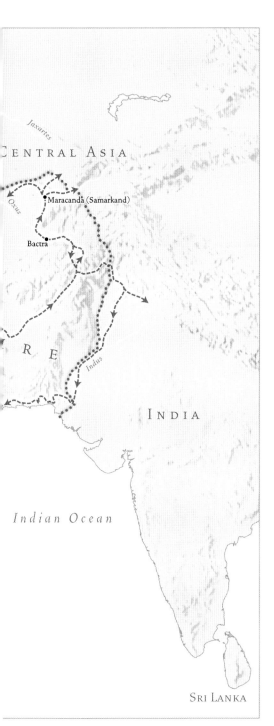

CENTRAL ASIA

Jaxartes

Oxus

Maracanda (Samarkand)

Bactra

R E

Indus

INDIA

Indian Ocean

Sri Lanka

MAP OF THE HELLENISTIC WORLD

◄---- Route of Alexander
 the Great
 ✕ Site of important battle
•••••• Seleucid Empire, 301 B.C.
•••••• Ptolemaic Empire, 301 B.C.

CHRONOLOGY

559–331 Achaemenid (Persian) control of Asia (Near East to India, south to Egypt)

Fifth century Herodotos reports that Artemis and Apollo are the children of Isis

480 Capture of Athens by Achaemenids; Acropolis burned

480/479 Battles of Salamis and Plataea (Greeks defeat Persians)

356 Birth of Alexander the Great, son of Philip II

336 Alexander ascends throne of Macedon; destroys Thebes and conquers Greece

333 Battle at Issos (southern Turkey); Alexander victorious over Persians; Ptolemy one of Alexander's generals

332 Alexander reaches Egypt/becomes pharaoh (according to the legend of Alexander)

331 Founding of Alexandria

Portrait of Alexander the Great, the so-called Guimet Alexander. From Egypt. About 300 B.C. Marble. Height 33 cm (13 in.). Paris, Musée du Louvre (Ma 3499). Photo: M. and P. Chuzeville.

Battle of Gaugamela (northern Syria); Alexander defeats Darius III (Achaemenids)

after 331 Alexander begins to use Persian diadem as royal symbol

323 On return trip from India, Alexander dies in Babylon; empire divided between his generals (Seleucus becomes governor from Syria to India; Ptolemy becomes governor of Egypt)

322/321 Alexander's sarcophagus sent to Memphis

306/305 Ptolemy becomes king/pharaoh of Egypt; founds house of Ptolemy, dynasty of Lagids

Ptolemies choose Dionysos and Herakles as divine ancestors; new blending of Egyptian and Greek gods (e.g., Aphrodite is merged with Isis); Osiris and Apis evolve into Serapis, who becomes a major god in Ptolemaic Egypt

297–283 Lighthouse built in Alexandria on island of Pharos

285 Ptolemy II ascends Egyptian throne

during 270s Ptolemy II marries Arsinoë II; she acquires title of "Ruler of Upper and Lower Egypt"; they become the first divine couple, *theoi philadelphoi* (brother- and sister-loving gods); double cornucopia designed by Ptolemy for the queen

Arsinoë promotes her image as Tyche, the New Aphrodite-Isis, Artemis; Heraclean and Dionysian links strengthened; merging of Dionysos and Osiris

Statue of Tyche. Greek, Hellenistic. 150–100 B.C. Island marble. Height 84.5 cm (33 ¼ in.). Malibu, J. Paul Getty Museum (96.AA.49).

(both connected with the claim to rule the East to India)

Rise of divine queen cult(s)

about 270 Arsinoë II dies

245 Ptolemy III ascends Egyptian throne; Third Syrian War begins; Ptolemy captures Antioch; Ptolemaic claim to rule Asia revived; Queen Berenike's famous dedication of her lock of hair at start of war

Murder of Berenike Syra, queen of Seleucid Syria and sister of Ptolemy III

238 Decree of Canopus (in three scripts; large number of regulations concerning Egyptian temples, among them that priests and priestesses are to be known by their finger rings)

222 Berenike II assassinated after death of Ptolemy III

Ptolemy IV ascends Egyptian throne; Arsinoë III his queen and sister

Fourth Syrian War begins (Ptolemaic claim to rule Asia revived); palace ship built; political control shifts to hands of advisors/court

204 Ptolemy IV dies and Arsinoë III is subsequently murdered; Sosibios controls government; house of Ptolemy saved by Macedonian guard

116–106 *Phosphoros* (light or torch bearer) role added to class of priests and priestesses under Kleopatra III

48 Caesar crushes Pompey's army; enters Egypt and sides with Kleopatra VII; Alexandrian War breaks out over Kleopatra's ascension to the throne

47 Ptolemy XIII killed; Caesarion (*Ptolemaios Kaisar*) born to Caesar and Kleopatra VII

44 Caesar assassinated

41 Kleopatra VII summoned to Tarsos (Turkey) by Mark Antony; Ptolemaic claim to rule Asia revived; in time Kleopatra bears three children by Mark Antony

Kleopatra and Mark Antony represent the New Aphrodite and the New Dionysos

31/30 Battle of Actium; capture of Alexandria by Octavian; Mark Antony and Kleopatra commit suicide; Ptolemaic dynasty ends

The gold jewelry treasure in the J. Paul Getty Museum carries with it the allure of the myth and mystery of Egypt. Fantasies of discovery and adventure, of wealth and glory, and of an untold story leap to mind in the presence of gold that has been hidden from sight for a couple of thousand years. Such is the reaction to the splendid pieces that make up the Getty's Ptolemaic jewelry [SEE FIGURE 1]. The ensemble includes two finger rings, a stephane (diadem), a pair of earrings with Erotes, two pairs of hoop earrings with animal heads, two snake armlets and two snake bracelets, and a hairnet, as well as beads of gold and semiprecious stone and several gold cowrie shells that could have belonged to one or more necklaces.

A treasure of such importance raises many questions, particularly, what is it and where did it come from? Was it formerly part of the splendor of a temple, where it perhaps decorated the statue of a goddess? Were the golden hairnet and the shining stephane ornaments for the hair of a priestess? Were the images of deities symbols of piety, or were they merely symbols of wealth? Were the delicate hoop earrings and the coiled snake armlets and bracelets affectionate gifts to a mother or a sister, or were they intended to adorn her on her last journey—to the funeral pyre—or to comfort her with earthly riches in the tomb? Could the jewelry have been worn at royal festivities to glorify the monarchy? Or could these pieces have been symbolic of the increasing wealth of a city on the rise? Is the treasure perhaps the last vestige of a tragedy? Was the jewelry worn by a victim of war or plunder or death? Did its onetime owner hide the gold so well that its whereabouts remained unknown after her demise? Is it a modern

assemblage or an ancient treasure? Was it chance that restored the golden treasure to modern wonder—and to all the questions and close examination?

Field archaeology rarely results in the the excitement of finding sensational objects. More often such finds are unearthed by chance or by illegal diggings, and for that reason they present real puzzles for archaeologists and art historians. Often only glimmers of their history remain by the time such pieces finally reach a museum or a collection. Researchers must then turn detectives in order to try to reconstruct the most essential aspects of the objects' original context, which is necessary if they are to be correctly interpreted and placed in their historical perspective. As it is devoid of any known provenance, the Getty jewelry assemblage presents such a challenge. But numerous clues contained in the objects themselves point to Egypt as the origin of the gold.

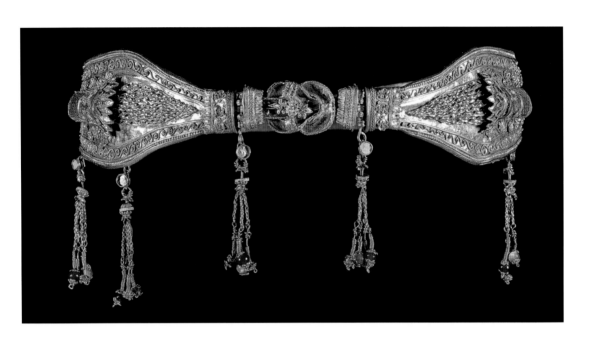

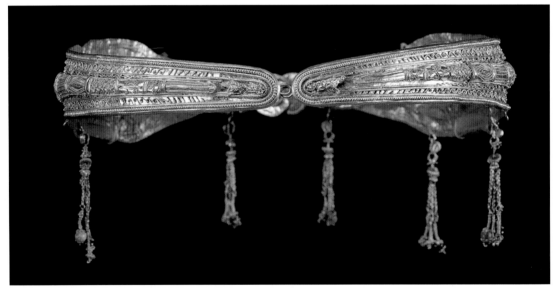

THE JEWELRY

One of the finger rings is set with an intaglio-carved orange-brown sard showing the figure of Tyche, the Greek goddess of good fortune [SEE FIGURES 24a–d]. The gem is fixed in a burnished four-stepped bezel created by a repoussé/chasing technique. The ring itself is not solid cast, but hollow, constructed from hammered sheet gold. The second finger ring is set with a carved carnelian depicting Artemis, the Greek goddess of hunting [SEE FIGURES 27a–d]. This ring is likewise constructed from hammered gold, but it weighs more than the first ring and is for a slightly larger finger. Its cabochon carnelian is translucent yet saturated red-orange in color.

Two beautiful and delicate hair ornaments add to the grandeur of the group of jewelry. The diademlike stephane [FIGURES 2a–b; SEE ALSO FIGURE 21d] consists of two leaf-shaped sides, each manufactured from one major piece of sheet gold. A torch with twisted ribbon "flames" is applied on each side [SEE FIGURES 21b–c]. The bodies of the torches consist of panels of designs created by complex applied filigree and decorative granulation. Surrounding the torches are floral tendrils springing from tiny calyxes of acanthus on each side of the back of the stephane [SEE FIGURE 21e]. The delicacy of these tendrils is in marked contrast to the heavier forms of the torch. In some areas the torches cover the tendrils, indicating that the torches must have been an ancient modification of the original design. The two sides of the stephane are joined with a double-hinge construction in the center front of the stephane, marked by a gold Herakles knot [SEE FIGURE 16]. The pins that hold the hinges in place are made of twisted wire, an ancient technique, and indicate that each hinge has

Figure 2a
Stephane, front view. Late third–early second century B.C. Gold, with carnelian, glass, and possibly shell. Diameter about 15.2 × 16.7 cm (6 × 6⅝ in.). Malibu, J. Paul Getty Museum (92.AM.8.2).

Figure 2b
Back view of stephane, figure 2a.

1

Figure 3a
Hairnet, side view
showing profile of
Aphrodite. Late third–
early second century
B.C. Gold sheet, applied
gold detail, with stone
(possibly garnet) beads
and inlays. Dome
height 6.5 cm (2½ in.);
diameter at base
8 cm (3⅛ in.). Malibu,
J. Paul Getty Museum
(92.AM.8.1).

Figure 3b
Three-quarter view of
hairnet, figure 3a.

opposite
Figure 3c
Medallion of hairnet,
figure 3a, showing
Aphrodite.

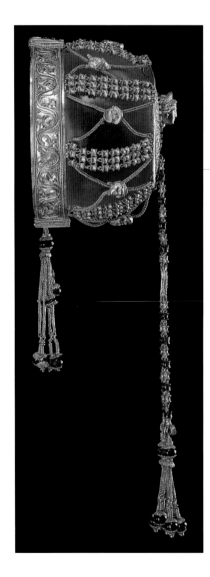

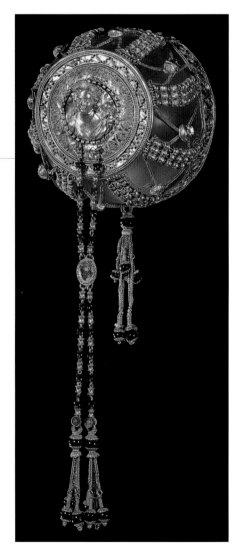

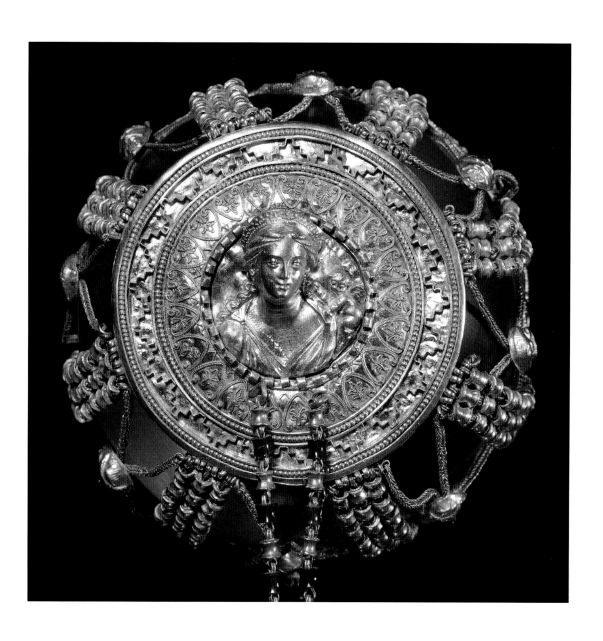

been preserved without any modern repair. Originally, eight groups of tasseled pendants hung at regular intervals from the bottom edge of the stephane [SEE FIGURE 2a]. The five surviving pendants are decorated with carnelian, crizzled green glass, and a very corroded ivory-colored material, probably shell [SEE FIGURE 21a].

The other hair ornament—an exquisite gold hairnet—consists of a central medallion, a patterned band that passed around the base of the wearer's hair bun, and the chains that link these two together [FIGURES 3a–c]. Ornamental double-strand tassels dangle from the medallion and from the patterned band [SEE FIGURE 32e]. The central medallion depicts Aphrodite with a tiny Eros tugging at the shoulder of her garment. The image is raised by repoussé from a single circular disk of gold sheet that was later chased for detail. The medallion is surrounded by a series of short tubes made of rolled sheet gold and probably originally inlaid with tiny colorful gems or perhaps pearls. Concentric bands of filigreed and applied decoration, constructed from twisted wire and beads or granules, surround the portrait of Aphrodite. The lower edge of the flexible dome consists of a narrow gold band decorated with a delicately applied filigree vine design with repoussé leaves, spiral-beaded wire, and granulated details [SEE FIGURE 32a]. The band is made up of two halves. As on the stephane, a Herakles knot joins the two sides on the top [SEE FIGURE 32b], but the true fastening was at the bottom with a pin (which is not preserved) through two simple loops of gold wire. Eight triple rows of gold spool beads connect the medallion to the band [SEE FIGURE 32c]. Between the spool rows are diagonal chains with small male and female repoussé masks where the chains intersect [SEE FIGURES 32f–i].

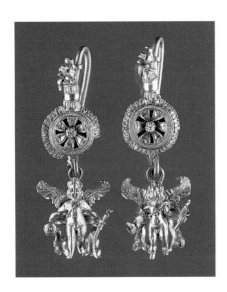

Figure 4
Earrings with Hellenistic Erotes, rosette disks, and bull heads. Late third–early second century B.C. Gold, with pearls. Height 4.5 cm (1 ¾ in.). Malibu, J. Paul Getty Museum (92.AM.8.5).

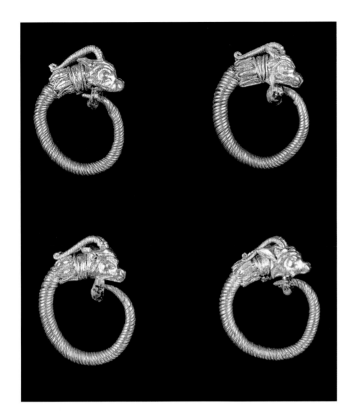

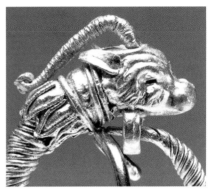

One of the three sets of earrings incorporates chubby figures of winged Erotes carrying torches [FIGURE 4]. The earrings, made up of over a hundred separate small components ranging from sheet gold to minute granules, are composed of three major segments: a bull head, a rosette, and an Erote [SEE FIGURES 22a–c]. Between the bull head and the rosette is a pearl. The Erote suspended from the rosette is composed of two sheet-gold repoussé halves soldered together. The wings, patera, torch, banners, and bandolier with granules are all separate features that were independently soldered onto the figure.

The two other pairs of earrings are identically manufactured hoops with antelope heads [FIGURES 5a–b]. This is the best-known earring type from the Hellenistic world, and these antelope heads display the typical characteristics—rounded, doelike features; circular eyes; and horns arching back over the head.

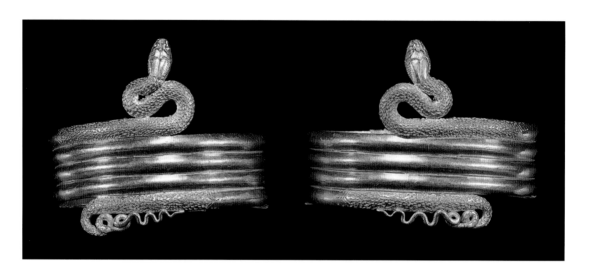

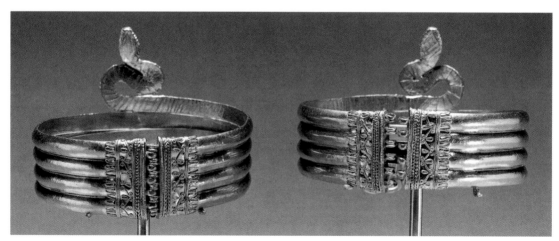

6

Pairs of snake armlets [FIGURES 6a–c] and bracelets [SEE FIGURES 35a–c] add to the exotic appeal of the group of jewelry. The bracelets and armlets so closely match each other in their technique and style that they must have been conceived as a set. Each of the heavy armlets consists of a single multiply coiled snake designed to encircle the wearer's upper arm. The bracelets, made up of four soldered gold coils, are each composed of two full snakes facing in opposite directions. All the snakes are embellished with decorative engraving and punching. As is usual for such pairs, the armlets and bracelets each form mirror images of the other. On the back of each is a hinged joint with elaborate filigree decoration [SEE FIGURES 6b–c]. The hinge was originally held closed by a pin constructed from a copper-alloy tube, which remains in place on one of the armlets [SEE FIGURE 6b, left]. Because copper is much harder than gold, it was often used to strengthen stress points such as clasps.

The last pieces in the jewelry assemblage are fragments of chains or necklaces. The strand of multicolored gems and gold consists of twenty-eight spheres and beads [SEE FIGURE 37]. The random arrangement of the beads is modern. The separate small polished orange carnelian with a drill hole in its stem is of a material similar to the carnelian beads in the strand. The short chain of hollow gold cowrie shells has no clasp, so it may originally have been longer [SEE FIGURE 36]. It consists today of twelve shells connected by strip-twisted double strands of gold wire. The decoration on the concave side of the shells is incised.

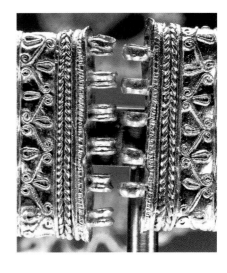

opposite
Figure 6a
Pair of matching armlets with single coiled snake. Probably late third–early second century B.C. Gold. Diameter about 7.6 × 6.9 and 7.1 × 6.7 cm (3 × 2¾ and 2¾ × 2⅝ in.). Malibu, J. Paul Getty Museum (92.AM.8.6).

Figure 6b
Back of armlets, figure 6a.

above
Figure 6c
Close-up of hinge of one of the armlets, figure 6a; pin missing.

7

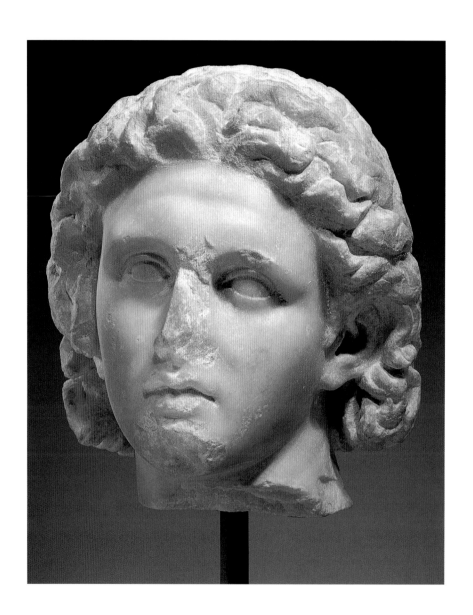

ALEXANDER THE GREAT:
A NEW GOD IN EGYPT

Greek gold from Egypt seems like a contradiction in terms since ancient Greek and Egyptian civilizations were as distinct as two cultures could be. Yet, at the time when this jewelry was created, the land of the Nile was no longer ruled by native Egyptian pharaohs but rather by Macedonian kings. In the court of these foreign kings, Greek culture seemed to triumph over the old world of the pharaohs.

The gold jewelry can be traced back to the third and second centuries B.C., when Greek culture had dramatically spread across the boundaries of the Greek motherland. It was a period when the influence of Greece extended as far as Persia and India, an age with Greek cities in Central Asia, and a time in which even the nomadic peoples from the Asian steppes were accustomed to Greek traditions. This era was linked as no other to a single man—Alexander the Great [FIGURE 7]. Without him and his legendary military campaigns there would have been no Greek culture in Egypt, no Graeco-Macedonian kings on the throne of the pharaohs, and no assemblage of jewelry.

In 336 B.C., at the age of twenty-one, Alexander ascended to the throne of Macedon, a region in the northern part of the Greek world around modern-day Thessaloniki. The Macedonians and the Greeks were not especially fond of each other, although the Macedonians did use the Greek language and had close affinities with Greek culture. The democratic Greek city states were strongly opposed to the social structure of the Macedonians, who were ruled by kings and a proud aristocracy. Open confrontation ensued when Philip II, the father of Alexander the Great, forced the splintered Greek world under Macedonian supremacy. When Alexander succeeded to the throne after the assassination of

Figure 7
Portrait of Alexander the Great. Greek, circa 320 B.C. Marble. Height 29.1 cm (11½ in.). Malibu, J. Paul Getty Museum (73.AA.27).

9

his father, the Greeks immediately rebelled and refused to surrender until Alexander's forces captured their proud city of Thebes, burned it to the ground, and sold its people into slavery. The destruction of Thebes opened the way for the young king to marshal his forces and the troops of his allies against the Persian Empire.

In the middle of the fourth century B.C. the empire of the Persian Achaemenids stretched from the coasts of modern-day Turkey and Syria to the borders of India, and from the Central Asian steppes of modern-day Tajikistan to the pyramids of ancient Egypt. Alexander's campaign against this vast and powerful empire was not an unprovoked act of war. In the early fifth century B.C. the Persians had captured the city of Athens and burned down the temples on the Akropolis. While the Greek victories at the battles of Salamis (480 B.C.) and Plataea (479 B.C.) had saved Greece from the Persian yoke, the Greek cities on the coast of Asia Minor continued to be at the mercy of the Achaemenid kings. Even though Alexander thus had the moral backing of the Greek world, native Macedonians and mercenaries formed the bulk of his legendary army. And while even Thracians, people from the northern fringe of the Greek world, were under Alexander's command, few Greeks served him. In fact, thousands of Greek mercenaries joined the ranks of the Persian army to fight against Alexander, and even after the most devastating defeat the Greek mercenaries stubbornly rejected Alexander's appeal to join the Macedonian army. Nevertheless, in a pivotal confrontation in 333 B.C. at Issos, on the southern coast of modern Turkey, Alexander crushed the Persian forces. This victory opened the routes to Syria, Palestine, and even Egypt.

It was at Issos that Ptolemy, the son of Lagos, first stepped into the spotlight of world history, and we get a glimpse of the man who was to rule Egypt and establish a dynasty [FIGURE 8]. The Roman historian Arrian reports that Ptolemy accompanied Alexander at Issos when the latter pursued the fleeing Persian king. Although not a member of the Macedonian nobility, Ptolemy became Alexander's personal bodyguard (*somatophylax*) and an important officer because of his military achievements and his friendship with the young king.

Alexander ultimately abandoned his pursuit of the Persian king and turned instead to conquering the coast of Palestine. He reached Egypt in 332 B.C., but not as a conqueror; rather, he came to rescue the Egyptians who had been

subjected to the Persian rule that had ended centuries of Egyptian sovereignty. The local Persian government capitulated, and the people of Egypt greeted Alexander and the Macedonians as their new rulers. In Memphis, the old Egyptian capital, Alexander ascended the throne of the pharaohs and became in the eyes of the Egyptians the new Horus, the falcon god (Pseudo-Kallisthenes 1.34.2). At the same time, he became the son of Osiris, the Egyptian god of the underworld and mythical king of Egypt, as well as the son of Ammon Re, the sun god whom the Greeks equated with Zeus—the supreme figure of the Greek pantheon. Thus, a young king from a provincial area of the Greek world suddenly emerged as a new god in Egypt.

In order to legitimize his divine status, the new pharaoh traveled west through the Libyan desert to the famous oracle of Ammon in the oasis of Siwah, where he was greeted as Ammon's son. Alexander and all the Ptolemies that were to follow him on the throne of Egypt were viewed as Macedonian kings, Egyptian pharaohs, and living gods. Educated in the cultural traditions of ancient Greece by the famous philosopher Aristotle, Alexander was suddenly the ruler of an Oriental kingdom whose traditions reflected thousands of years of history. To the Greek mind this could not have been more mysterious or exotic.

In 331 B.C. Alexander left Egypt, never to return there again—alive. Before departing, he founded on the Mediterranean coast a new city that bore his name — Alexandria. Within a few years Alexandria not only became the new capital of Egypt, but it also emerged as the most important center of the Mediterranean. However, before this could happen Alexander still had to assemble his forces for a decisive battle against the Persians. In 331 B.C. at Gaugamela, near the river Tigris in Assyria, Alexander defeated Darius III, and the Persian Empire of the Achae-

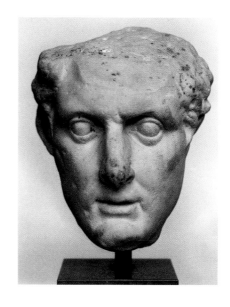

Figure 8
Portrait of Ptolemy I.
Allegedly found in the
Fayum. About 300 B.C.
Marble. Height 26 cm
(10 ¼ in.). Copenhagen,
Ny Carlsberg Glyptotek
(cat. no. 253a).
Photo: Jo Selsing.

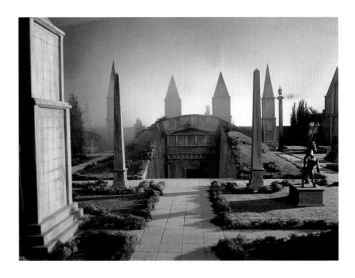

menids finally collapsed, thereby ending its lengthy threat to the Greek and Egyptian worlds.

After this brilliant victory Alexander stormed through Asia, reaching the borders of India before returning to Babylon in 323 B.C. In this old Mesopotamian capital, Alexander suddenly died. He was thirty-three years old. This unexpected event forced his generals, who had been busy preparing for new campaigns and conquests, to arrange for Alexander's succession. The nobility of Macedon divided the newly expanded empire among Alexander's generals. One of the many governors soon to depart for their new regions was Ptolemy, son of Lagos, who had arranged to rule Egypt. With authority over this old pharaonic realm Ptolemy gained control of one of the most important parts of Alexander's empire.

Ptolemy did not enter Egypt as a king. He assumed that title in 306/305 B.C., however, thereby founding the house of Ptolemy and the dynasty of the Lagids, which was to rule Egypt until the death of the famous Kleopatra VII, in 30 B.C. To celebrate the deified founder of the dynasty of the Lagids, the kings were all named Ptolemy; they were distinguished by second names such as Ptolemy I Soter (the savior), Ptolemy III Euergetes (the benefactor), and Ptolemy IV Philopator (the one who loves his father).

Alexander's embalmed body was returned to Egypt in a golden sarcophagus and chariot in 322/321 B.C. A tomb was prepared for him in the old capi-

tal of Memphis, but within a few years Ptolemy I had the body transferred to the new capital of Alexandria [FIGURE 9]. There the founder of an empire who had ushered in a new age found his final resting place within a circle of Ptolemaic tombs that would grow over the next two centuries. The divine king was so important for the legitimization of the new dynasty of the Ptolemies that its first silver coins were issued with the portrait head of Alexander the Great. On these coins Alexander is sometimes portrayed with a miniaturized Indian elephant skin on his head as a symbol of his triumph in India. Instead of or in addition to the elephant tusks and trunk, Alexander is also often shown with ram's horns over his ears [FIGURE 10], which refer to his descent from the Egyptian ram-horned god Ammon. Alexander is furthermore often depicted draped in an aegis bordered by snakes, an attribute of Zeus, the main god in the Greek pantheon. These unique attributes celebrate the ascension of a new god.

After Alexander's death, oracles prophesied that the country that held the body of the legendary king would be extremely powerful and wealthy (Aelian *Varia Historia* 12.64). These prophecies proved true: In the third century B.C. Egypt was in control of almost all the coastal regions of the eastern Mediterranean, and, as a superpower with a strong naval presence, she more or less regulated trade and commerce. To maintain their wealth and position, the Ptolemies, just like the ancient pharaohs, battled endlessly with Syria and Mesopotamia. Their main enemy was the Seleucid Empire, founded by another of Alexander's generals, whose realm stretched from Syria to the borders of India. The Ptolemies and the Seleucids were perennial enemies. The so-called Syrian Wars typified the political relations between the two realms, which were characterized by frequent transitions between peace and bloody war.

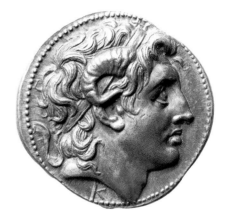

Figure 10
Tetradrachm of Lysimachos. Obverse: Alexander as son of Zeus-Ammon, with ram's horn and diadem. 317–309 B.C. Silver. London, The British Museum (1919.8-20.1).

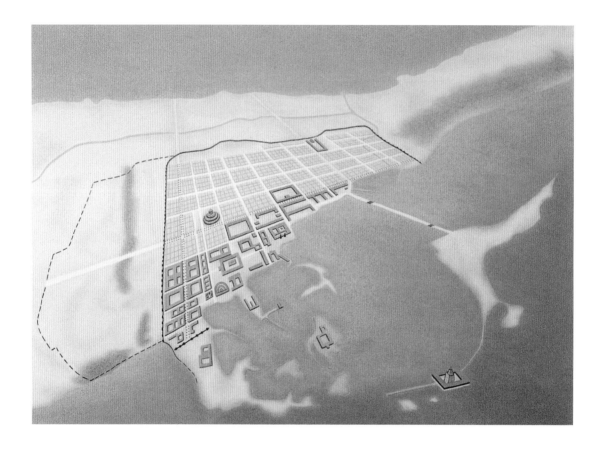

Figure 11
Aerial view of Alexandria
in the time of the
Ptolemies. The harbor
with the Pharos looking
north over the Medi-
terranean Sea is in the
foreground. Drawing:
Ulrike Denis.

Figure 12
Reconstruction drawing
of the Pharos, the
lighthouse of Alexandria;
built between 297
and 283 B.C. Original
of stone, height 120–
140 m. From H.
Thiersch, *Pharos, Antike,
Islam und Occident*
(Leipzig 1909),
foldout frontispiece.

ALEXANDRIA, A NEW CITY
IN AN OLD WORLD

In the romantic tradition of Alexander's biography, Serapis (a god combining Egyptian and Greek characteristics, invented by Ptolemy I) appeared in one of Alexander's dreams. Quoting Homer, the god directed Alexander to the site where he was to found his new city, Alexandria [FIGURE 11]. The city not only exploited the wealth of Egypt but also imported luxury items from places as far away as India. To protect the ships entering its rather dangerous harbors, Sostratos of Knidos was commissioned to erect a gigantic lighthouse. The lighthouse was built between 297 and 283 B.C. [FIGURE 12] on the island of Pharos, from which it took its name. Some 120–140 m high, the lighthouse must have been regarded in antiquity as a skyscraper. Its construction cost more than eight hundred talents—the equivalent of 20,800 kg of silver. The Pharos, which was

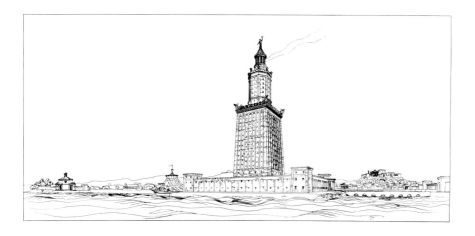

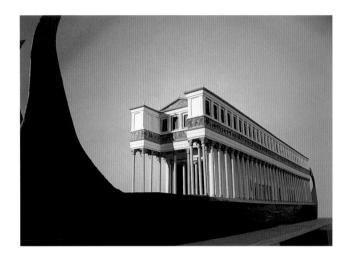

one of the Seven Wonders of the Ancient World, survived into the fourteenth century A.D. when it was destroyed by an earthquake.

Alexandria was most definitely a royal city. The geographer Strabo states that palace quarters once occupied a quarter or perhaps even a third of the city. The older palaces were located on Cape Lochias, where each Ptolemy erected his own palace more or less adjacent to those of his predecessors. The palace—an essential royal symbol—even mutated into a ship in the form of the famous catamaran *Thalamegos* [FIGURES 13a–b], created under Ptolemy IV (r. 222–204 B.C.) for traveling on the Nile and its tributaries. However, much like the other examples of Ptolemaic architecture discussed below, the cabin on this ship had features much more closely linked to a Macedonian palace than to an ancient ship. In fact, although Ptolemy IV functioned as an Egyptian pharaoh, like the Ptolemaic line before him, the only Egyptian elements in his palace ship were found in a single room on the upper deck.

Just as the Getty jewelry alludes to Egyptian ideas, although its ico-nography is Greek, so the same cultural blending is represented in Alexandrian tombs—some of the only examples of Alexandrian architecture of the Ptole-

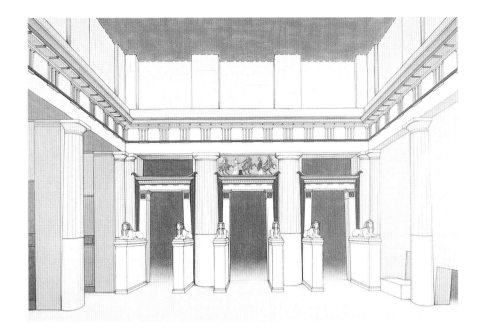

Figure 14
Reconstruction drawing
of peristyle courtyard
of Tomb 1 of Mustafa
Pasha. Hellenistic
era. University of Trier,
Archaeological Institute,
Drawing Collection
(1996.17B). Drawing:
Ulrike Denis. © Michael
Pfrommer.

maic period to survive. The metropolis, and especially the royal quarters, suffered extensive damage in the times of the Roman emperors. The city center was literally rebuilt beginning in the nineteenth century. Consequently, not even a single ground plan from an Alexandrian house exists today. The same holds true for Alexandrian palaces, including the palace of Kleopatra VII, which has so often sparked the imagination.

Although deplorably few remains survive, we know that the Alexandrian nobility lived in houses of Greek style with central colonnaded courtyards, similar to the one seen in an important tomb that actually incorporates such a peristyle [FIGURE 14]. As in Greek houses, there was a massive balustrade above the columns abutting the flat roof. Oriented toward these inner courtyards, Greek houses may have presented facades that were not very appealing aesthetically.

The rather restrained nature of the exteriors of ordinary homes was, however, in marked contrast to the exteriors of royal palaces. In addition to playing a religious role, Egyptian kings represented the state. Their architectural representations had to be opulent and even dramatic. Their palaces and temples were constructed with impressive facades, huge rows of colonnades, and com-

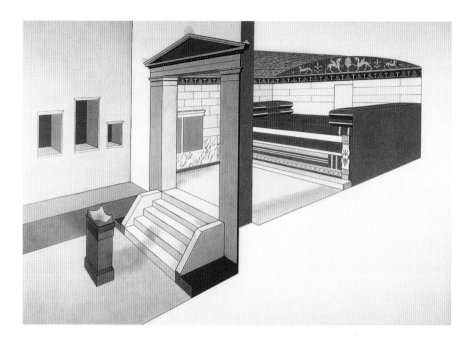

Figure 15
Reconstruction drawing
of interior of templelike
tomb from Sukh el-
Wardian (Alexandria)
with *kline* (dining couch)
and altar. Late third–
early second century
B.C. University of Trier,
Archaeological Institute,
Drawing Collection
(1998.1B2). Drawing:
Ulrike Denis. © Michael
Pfrommer.

plex entrances that prepared the visitor for his step up to a higher level of the world. A brilliant example of this architectural language is preserved in the ancient description of the ship palace of Ptolemy IV [SEE FIGURES 13a–b, 31]. There windows had become a dominant feature of the architectural language, despite the fact that those windows were probably always kept closed. Both the window motif and the whole structure of these buildings are reminiscent of the palaces in the Macedonian homeland of the Ptolemaic kings. The royal architecture, like the jewelry of the Alexandrian nobility, reflected Macedonian descent. The interior of private houses and palaces must have been decorated by colorful mosaics like those discovered most recently in the eastern palace quarters in Alexandria. One mosaic depicts with striking realism the dog of the patron; another shows a scene with two men wrestling.

The Alexandrian tomb easily passes as an entirely Greek structure until we notice the row of Egyptian sphinxes protecting the tomb and the deceased [SEE FIGURE 14]. The interior chambers of tombs sometimes took on the illusion of Greek temples, as illustrated in FIGURE 15 by the inner entrance with its steps and pediment and an altar for votive offerings. But within the

chamber, where we would expect the statue of a god in the case of a temple, we encounter a magnificent *kline* (dining couch), a symbolic resting place for the deceased. Just above the *kline* is a small niche meant to hold the remains of the deceased. By the time the Ptolemies had tombs like this one, the afterlife of the dead was thought to be better than it had been in the traditional Greek view. According to Homer's description of the fate of his most brilliant heroes, such as Achilles, the Greeks believed that a person—even a hero—became nothing but a shadow in the unpleasant dark world of Hades, the Greek afterworld. The far more appealing Egyptian view of the afterlife saw the deceased fuse or merge with the god Osiris, a fact that may explain the rise of new religions such as the Dionysian mysteries, which offered at least some sort of desirable afterlife. Perhaps Egyptian iconography and style were not the catalysts for the blending of the two cultures, but the Egyptian way of thinking certainly seems to have taken its place in the mixture.

Despite the legend about Alexander the Great's founding of Alexandria, recent discoveries in the muddy waters of the harbor of Alexandria by underwater archaeologists have revealed grand monuments in pharaonic style created many centuries before Alexandria became a Ptolemaic city. The inscribed names of the pharaohs rising out of their wet tomb include Ramses II (r. 1290–1224 B.C.) and his father, Sethos I (r. 1304–1290 B.C.), both representing an era when pharaonic Egypt ranked among the leading powers of the Mediterranean. This status was restored under the reign of the Ptolemies. The third century B.C. easily rivaled the most brilliant periods of Egypt's pharaonic past. These previously submerged monuments have certainly stimulated today's interest in the Egyptian past; it is not difficult to imagine that they might have contributed greatly to a rising Egyptian aesthetic in the new capital at the time of Ptolemies' rule.

We can be sure that Egyptian influence, or at least the acceptance of Egyptian ideas, increased over the centuries. At the end of the third century B.C., Ptolemy IV and his sister/wife, Arsinoë III, were the first Ptolemaic rulers to call the Egyptians to arms and to have them trained in Macedonian military tactics. Seleuco-Syrian forces in Palestine threatened the very existence of the Ptolemies and forced this mobilization. The enemy was defeated, but the price for

the success on the battlefield was a rise in Egyptian nationalism. This growing Egyptian ambiance, however, remained an alien concept in Alexandria—a primarily Greek city in the third century B.C. Ancient authors insisted that the Ptolemaic metropolis was located "close to" but not "in" Egypt. Additionally, although Alexandria was indeed multicultural, members of the Greek elite continued to try to protect their advantages in the face of a large country that maintained its own pharaonic traditions. An example of the differences can be seen in the two cultures' views of their rulers. The Greeks viewed the Ptolemies as mortal Macedonian kings; accordingly, each succeeding Ptolemy had to garner the respect of his forces and of the Macedonian guard. To the Egyptians, however, the Ptolemaic pharaohs were gods or living images of gods. As such they had to guarantee the well-being of their subjects and their world, and they were even held responsible for adverse incidents—including uncontrollable events of nature such as the absence of the flooding of the Nile.

To the Ptolemies and the Greek elite, Egypt remained a conquered territory, a fact illustrated by ancient historians who recounted that she was won by the spear. Given this background, it is not surprising that the Getty gold represents the exclusively Greek elements of Ptolemaic society. We must keep in mind that the term *Greek* refers to kings who were actually of Macedonian descent, and consequently we can expect to find some allusions to Macedonian trends and motifs in their art.

The Greek affinities of the Alexandrian nobility are embodied in the golden stephane that once decorated the hair of an upper-class lady [SEE FIGURES 2a–b]. The stephane was created in the late third or early second century B.C., in the days of the fourth or fifth Ptolemy. Like their kings, much of the nobility of Alexandria had Macedonian ancestors. They traced their origins back to Herakles and therefore ultimately to Zeus, the father of this most famous hero. It is therefore not surprising to find a Herakles knot, a symbol of this descent, in the center of the elaborate stephane [FIGURE 16]. This central motif functions as an apotropaic symbol, to ward off evil. Such knots were important in many cultures, including ancient Egypt, where they were found in hieroglyphics as the *ankh*, the holy symbol of life. The supposed apotropaic power of knots was recognized and valued even in the times of the earlier Egyptian

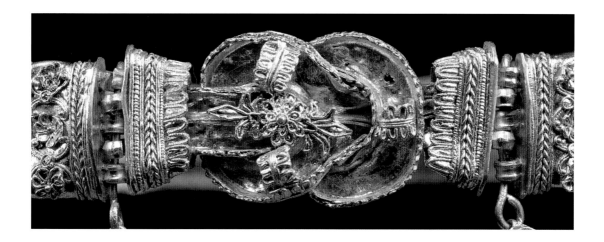

dynasties, during the period of the pyramid builders, two thousand years before the Ptolemies. However, since the Getty knot is entirely in Greek style, it seems more appropriate to look for its Greek connotations.

To free himself and gain acceptance from the gods, Herakles had to complete twelve labors, of which the first was killing the Nemean lion. The ferocious animal had an invulnerable hide, so the hero had to strangle him and then use the lion's claws to skin it. Throughout his life Herakles prized the hide as a trophy; he wore the scalp on his head like a helmet and tied the front paws of the animal's hide in a knot under his chin. FIGURE 17 shows how this "Herakles knot" was tied.

Herakles knots often appear on drinking vessels, especially those linked with the hero. The knot was also incorporated into wedding ceremonies, where the bride's dress was tied with these magic knots. The knot was believed to be especially beneficial for women's protection during childbirth and motherhood. As such, it was a very appropriate element for pieces of jewelry. The knot was also linked to the rise of the Greek pantheon. The father god

Figure 16
Front of stephane, figure 2a, showing Herakles knot and double hinges with pins; inlays missing from bezels and knot.

Figure 17
Schematic drawing of a Herakles knot. Drawing: Toby Schreiber.

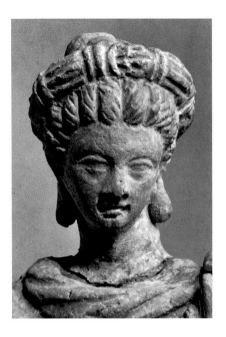 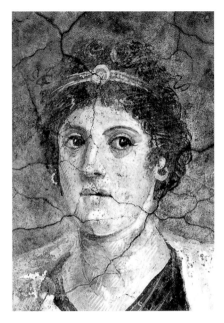

Figure 18
Statuette of woman
wearing a stephane with
a Herakles knot (detail).
From Myrina. 50–20 B.C.
Terra-cotta. Height
of statuette 22.5 cm
(8⅞ in.). Munich,
Antikensammlungen
(SL 246). Photo:
Christa Koppermann.

Figure 19
Berenike II wearing
a stephane with
a medallion (detail).
From Roman
villa at Boscoreale.
First century B.C.
Wall-painting. New York,
The Metropolitan
Museum of Art, Rogers
Fund, 1903 (03.14.5).

of the Greeks, Kronos, was believed to have coupled with his sister and fellow Titan Rhea in a serpentine fashion—like divine snakes intertwining in a Herakles knot—and thus to have produced a whole generation of gods.

Although these and similar knots were highly valued for their magical power, it was not until the time of Philip II and Alexander the Great that Greek jewelers first developed an artistic concept for the sacred knot. Despite appearing quite late in the history of Greek jewelry, the Herakles knot nevertheless dominated the world of Hellenistic jewelry. The explanation for its sudden popularity is not difficult to discern. The era of Alexander and the two following centuries, which were dominated by Macedonian dynasties, are replete with Herakles iconography. Although pieces of jewelry with the Herakles knot were very fashionable in this period, the use of the motif should not be seen exclusively as an allusion to the owner's Macedonian descent. Even though this connotation is likely, the use of these knots also shows a trend toward magical symbolism in jewelry. The knot of the Getty stephane illustrates that its ancient owner was completely aware of the dominating trends of her time. It is the centerpiece of an elaborate headdress, and it was meant to rest directly above the forehead of its wearer. A number of small terra-cotta statuettes show a stephane

with a Herakles knot [FIGURE 18]. In another view of how a stephane would have looked when it was worn, FIGURE 19 illustrates the Ptolemaic queen Berenike II (r. 245–222 B.C.) from a wall-painting in a Roman villa in Boscoreale that was buried by the eruption of Mount Vesuvius in A.D. 79. (Berenike's stephane, however, has a medallion and not a Herakles knot in the center.)

Today these headdresses are most often referred to as diadems (a crownlike ornament), but "stephane" (headdress) is the more appropriate term for the present discussion, for it does not imply royal rank. In antiquity a diadem was a very special item that was linked almost exclusively to Alexander the Great, his successors, and the sphere of kings. It was simply a purple textile band that was rarely decorated. Originally, diadems were part of the royal accoutrements of the Achaemenid kings; when Alexander captured the Persian Empire, he incorporated some of their regal elements into his royal costume. Accordingly, the bandlike diadem, tied in the hair with its tasseled ends dangling on the neck or flowing around the shoulders, came to symbolize kingship. No man except the king himself could wear or even touch the diadem, as illustrated in a famous story about Alexander and his diadem. During a boat excursion in Mesopotamia the wind swept the diadem off the king's head and carried it away. An ordinary sailor volunteered to rescue this symbol of the king and dove into the water. He was successful in retrieving the diadem, but in order to protect it, he put it on his own head, and by so doing gambled with his life. The action could have sentenced him to death for having profaned the symbol of kingship. Luckily he was given a monetary reward instead. Because the diadem is a symbol of royalty, applying the term to the Getty piece might suggest a royal status for the anonymous owner—a conclusion that cannot be corroborated in this case.

The style of Hellenistic Herakles knots on jewelry changed over time, and therefore the knots provide a good chronological framework for dating. In the early Hellenistic period—the late fourth and early third centuries B.C.— gold knots without stone-inlaid bands were most common. This is exemplified by the golden knot on a bracelet from Toukh el-Quaramous [FIGURE 20]. Discovered in the ruins of a small sanctuary in the eastern part of the Nile Delta, the bracelet was part of a treasure that was buried around 250–240 B.C. It was discovered when a donkey stepped on an earthenware vessel that had been hidden

just below the surface of a path for more than two thousand years. While helping the animal out of the hole, the lucky Egyptian peasant suddenly had his hands full of ancient gold.

In contrast to early knots, the Herakles knot on the Getty headdress was probably decorated in the less usual way with glass paste. It therefore reflects the fashion of color inlays from the second half of the third century B.C., a style that would continue to dominate the subsequent century.

Although decorated with the Herakles knot and further elaborated with tassels [FIGURE 21a], the stephane's most striking feature is the torchlike element on each lateral arm [FIGURES 21b–d]. Made of several strands of narrow, torn sheets of gold, the pointed tops of the gold torches depict flickering flames and smoke. The elaborately ornamented and segmented shafts of the torches represent tightly bound stalks of plants, some of which bulge. The torches are also decorated with lozenge-shaped elements, scale patterns, cross-hatching, and, directly beneath the flames, an arrangement of ivy leaves. Both torches are bordered above and below by tiny flower tendrils from acanthus calyxes [FIGURE 21e].

The use of torches was widespread and not limited to any special cult. Torches are known from Dionysian festivals and as attributes of deities such as Demeter and her daughter, Persephone, who are all closely linked to the underworld. We know of torches also in connection with weddings. This implies that torches had a generic religious connotation. However, the extensive use of torches by dynastic priests in Ptolemaic Egypt is corroborated in particular by the introduction of a new class of priests during the reign of Kleopatra III (116–106/105 B.C.). She added a *phosphoros* (torch bearer) to the already extravagant number of dynastic priests and priestesses, which indicates that torches were probably used in a very wide range of religious contexts. Consequently the stephane's exceptional torch motif in all likelihood points to a cult role for the anonymous owner of the jewelry.

The Herakles knot and the ivy on the torches may even suggest a dynastic cult. Ivy was a symbol for the orgiastic god Dionysos. Herakles and Dionysos were the gods the Ptolemies had chosen as their divine ancestors. The preference for Dionysos is not surprising, for in Greek mythology he had conquered India, a feat paralleled by the Ptolemies' chosen human ancestor, Alexander. In

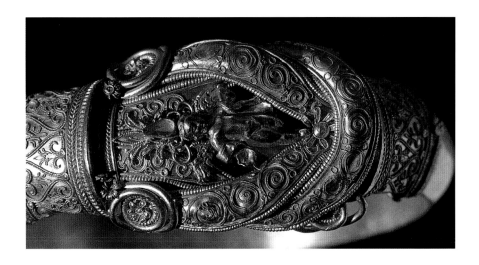

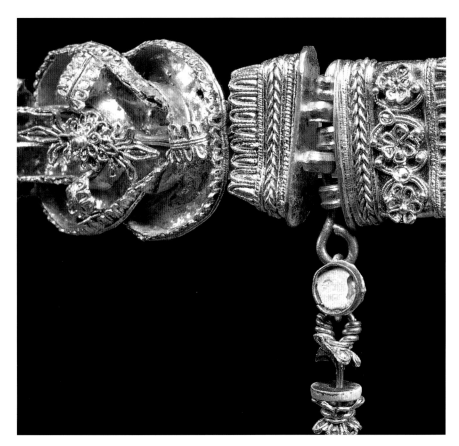

Figure 20
Bracelet with early
Herakles knot. From
Toukh el-Quaramous,
Egypt. Second quarter
of third century B.C.
Gold. Diameter 9.5 cm
(3 ¾ in.). Cairo,
The Egyptian Museum
(JE 38077).

Figure 21a
Tassel from stephane,
figure 2a, with
carnelians and bezel for
paste or shell inlays.

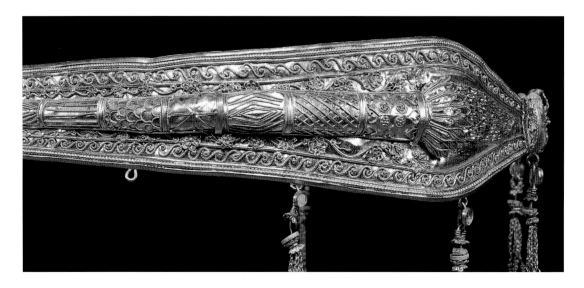

Figure 21b
Side view of torch
on stephane, figure 2a.

Figure 21c
Flame of applied torch
on stephane, figure 2a.

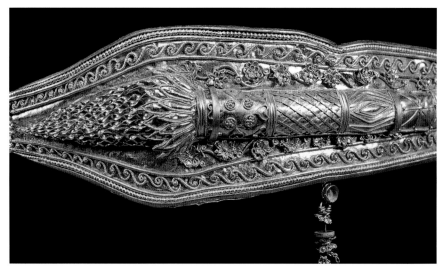

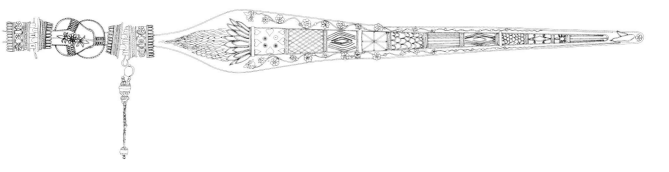

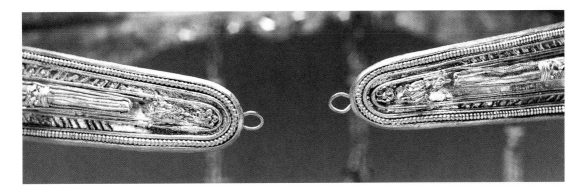

the eyes of the Ptolemies history had repeated its mythical past. In Alexandria the cults of the divine queens were also of prime importance. Each of the famous queens had her own priesthood, and we know of a special cult for a princess who died at the age of eight. We even know the names of many of these priestesses. Noble families vied with each other for these honored positions, some of which were even held by the courtesans of the Ptolemies. One such cult existed for one of the most famous courtesans of Ptolemy II (r. 285–245 B.C.); she was deified as an embodiment of Aphrodite, and her cult still prospered more than two centuries later, during the time of Augustus.

Given the symbolism of Herakles and Dionysos on the stephane, and in view of the finger rings discussed below, it seems entirely possible that the anonymous owner once belonged to the exclusive circle of dynastic priestesses, one of the cults of the divine queens.

top
Figure 21d
Rollout drawing of stephane, figure 2a. University of Trier, Archaeological Institute, Drawing Collection. Drawing: Ulrike Denis.

Figure 21e
Back of stephane, figure 2a, showing loops for closure.

27

THE GOD OF LOVE
AS KING OF EGYPT

The Ptolemies continued to draw the gods from their Greek traditions into the Alexandrian blend of cultures. It is no surprise, therefore, to find two tiny figures of Aphrodite's son, Eros, the Greek god of love, as pendants on one of the beautiful pairs of earrings [FIGURES 22a–c; SEE ALSO FIGURE 4]. These unique earrings represent a blend of two well-known types: bull-head earrings and earrings with Eros suspended beneath a decorative disk. The Erotes, who carry torches and flutes in their hands, are shown as babies and therefore belong to the Hellenistic period. In the Classical period (480–323 B.C.) Eros would have been represented as a half-grown boy with long wings. The winged baby god, the son of the goddess of love and beauty, was usually equipped with a bow and arrows. His arrows delivered a message of love, but also the message that love could hurt the recipient. As a messenger of love, Eros was widely represented on jewelry; wearing this type of jewelry might represent a desire both for love and for physical beauty.

In the case of the Getty pendants, Eros has exchanged his weapon for a torch. We have already suggested that the stephane with its torch motif once belonged to a priestess linked with a cult of the divine queens. As royal deities these queens were meant to represent the Greek and Egyptian worlds, and they were consequently identified with Greek and Egyptian goddesses. The Greek subjects of the Ptolemies in most cases equated the queens with Aphrodite, whereas the Egyptians perceived the queens as Isis. The Egyptian goddess Isis was a far more complex deity than Aphrodite. As her name (meaning "the throne") suggests, she was closely linked with the royal family. According to

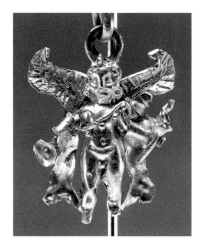
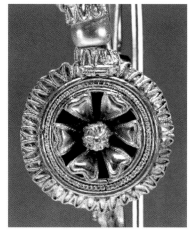
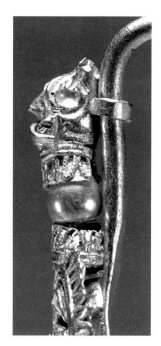

Egyptian beliefs, Isis was actually the mother of every pharaoh. Since the most famous queens were represented as Aphrodite and Isis concurrently, the two queen-goddesses began to be perceived as manifestations of a single deity.

We can easily imagine that this blending of the deities was an effort to combine the religious concepts of two different worlds, and it was a strategy that had huge consequences for the interpretation of individual gods. In the land of the Nile the falcon god Horus was the son of Isis and ruler of Egypt. As soon as Isis merged with Aphrodite, it was almost inevitable that Aphrodite's son, Eros, would be perceived as the equivalent of Horus, or the divine young pharaoh, and obviously he would be linked to the royal house in Egypt. Following this argument, the Eros pendants would be very appropriate for a dynastic priestess.

The tiny Erotes are combined in an exceptional way with the animal-head, or, more specifically, bull-head earrings. The bull-head type of earring was introduced in the third century B.C. and was widely produced in Egypt for many centuries. The reason for this rather unique blend of the two types of jewelry

Figure 22a
Eros from earring, figure 4; he is portrayed as a baby carrying a torch and flute.

Figure 22b
Rosette disk from earring, figure 4; note pearl between disk and bull head (top).

Figure 22c
Side view of bull head from earring, figure 4; pearl between bull head and rosette.

29

could simply be aesthetic, without any deeper meaning. On the other hand, since we have just suggested that the god of love had acquired royal status, it is tempting to try the same reasoning for the bull.

In contrast to Greek belief, Egyptian gods nearly always had an equivalent in the animal world, which accounts for the strange appearance of many Egyptian deities (e.g., the man/falcon god Horus). The bull of Apis played a major role in Egyptian religion, and the Egyptians actually worshiped the Memphis god in the form of a living bull. They even prepared exquisite sarcophagi for these animal gods. When the Persian king Cambyses captured Egypt in the late sixth century B.C., he reportedly forced the priests of Apis to sacrifice and eat their living bull/god; it is difficult to imagine a more obscene and blasphemous act, conceived to humiliate the Egyptians. The story illustrates the place the bull occupied in Egyptian belief and history.

Like other Egyptian gods, Apis had his Greek equivalent. He was equated with the Greek hero Epaphos. The Greeks believed Epaphos was one of the mythical pharaohs of Egypt and the founder of the pharaonic capital of Memphis. Although Epaphos was considered a true pharaoh, like most Greek heroes he was actually the offspring of a god and a mortal. The god Zeus had fallen in love with the beautiful mortal Io, ironically a priestess of his own wife Hera. The ever-jealous Hera was a constant threat to the young Io, so Zeus transformed Io into a cow. Hera, not deceived at all, forced Zeus to give her the cow and then had the animal closely watched by Argos, the giant with a hundred eyes. Although the messenger god Hermes freed the poor cow, Zeus did not transform her back into a human. The invidious Hera tortured the cow/woman by means of a relentless horsefly. Desperate, Io fled, first to the Caucasus and ultimately to Egypt, where she was amiably greeted by Isis and finally transformed back into a human being. The moment she became a beautiful woman again, Zeus reappeared and fathered Epaphos with her. It is not surprising then that Epaphos might be seen as a bull, since his mother had spent part of her life as a cow. This story must have been highly symbolic for the Ptolemies, for they had a divine ancestor in common with Epaphos.

This fanciful legend of the beleaguered fugitive seemed to repeat itself when Arsinoë II, the wife and sister of Ptolemy II, fled to Egypt to escape her

second husband, a connection represented in the portrait of Arsinoë II with the cow horns of Io [FIGURE 23]. Of course, there is no archaeological need to identify the bull-head earrings with the Apis bull. However, any educated Ptolemaic subject who believed Eros symbolized divine royalty could view the bull similarly—and both would be appropriate for representation on jewelry. What in other parts of the Greek world would have been understood as a conventional motif, with its source in Greek mythology, would in Egypt have been understood as royal and divine.

The remarkable bull/Eros pendants have yet another unusual feature that reflects the opulence of the time. Beneath the bull heads the goldsmith has delicately incorporated a small pearl on each pendant [SEE FIGURES 22b–c]. Very rare in Ptolemaic jewelry, pearls were highly prized in the late Hellenistic period (ca. 150–30 B.C.). Of greatest renown are the pearls in Kleopatra VII's earrings. The queen once bet her Roman lover Mark Antony that she alone could consume a meal worth ten million sesterces. The general laughed at her, believing that his beloved queen could never eat the sum that was sufficient to feed the population of a small city. At the height of the festivities the servants presented Kleopatra with a cup of vinegar. The queen threw one of her priceless pearls into the fluid, and when it disintegrated, she drank the liquid; Mark Antony lost his bet. After Kleopatra's suicide, the second earring was taken as a spoil of war to Rome, where it decorated the ear of a statue of Venus, the Roman Aphrodite.

The Roman writer Pliny the Elder tells us that pearls first became known in Rome at the end of the second century B.C., but they came into common use there only after the capture of Alexandria in 47 B.C.

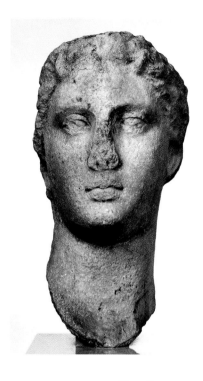

Figure 23
Portrait of Arsinoë II with horns of Io. About 275–250 B.C. Marble. Height 44 cm (17 3/8 in.). Paris, Musée du Louvre (Ma 4891). Photo: P. Lebaube.

The main sources for pearls, as quoted by Classical writers, were the Persian Gulf and India. The Red Sea is frequently given as the source of pearls in ancient literature but this—the Mare Erythrium—is not the Red Sea of present terminology but the sea all the way around Arabia, including the Persian Gulf. There is minimal evidence that the Red Sea of modern terminology supplied pearls in antiquity. No ancient authorities specifically mention pearls from the Egyptian coast of the Red Sea although pearls passed via the Red Sea ports and Alexandria *en route* for Rome. The only possible evidence we have for the presence of pearls in the Red Sea off Egypt in Roman times is a dedicatory inscription found at a mining settlement in Wadi Semina. The inscription, dating to between AD 17 and 37, honours a man who, among other positions was 'chief of the overseers of the mines of emeralds (*smaragdou*), peridot (*baziou*), pearls (*margaritou*), and all the minerals of Egypt.' (Jack Ogden, "Report on a Group of Ptolemaic Gold Jewelry," *Independent Art Research, Ltd.* [1992], p. 12.)

The pearls on the Getty earrings cannot be dated. However, since the assemblage belongs to the late third or early second century B.C., the earrings could be among the earliest use of pearls known to date.

The evidence for the blending of Egyptian beliefs and Greek iconography becomes clearer as we continue to investigate the jewelry. It is time to turn to the powerful women who were catalysts for such a magnificent blending of cultural elements—and for much of the dramatic history of the Ptolemaic dynasty.

POWERFUL QUEENS:
FROM ARSINOË II TO KLEOPATRA VII

Many ancient societies were patriarchal. Almost completely banned from politics, women could exert their influence only surreptitiously, if at all. This is underscored by the fact that from the Classical period of Greek history (480–323 B.C.) we know the names of very few women who succeeded in shaping history. Never did a Roman empress sit alone on the throne of the Caesars and actively direct the affairs of that ancient superpower. In only one Mediterranean kingdom do we meet powerful queens from the earliest period—Ptolemaic Egypt. Once again there are certain parallels to ancient Macedon. There Olympias, the greatly feared mother of Alexander the Great, was killed at the age of eighty in order to put an end to her power. The Macedonian queen Eurydike, married to the imbecile successor of Alexander the Great, actually joined her troops on the front line of battle. These two strong characters may have opened the door to the acceptance of women as rulers, at least in extraordinary cases or situations. Many Ptolemaic queens followed their pattern and even surpassed the ambitions of their Macedonian ancestors. Kleopatra VII, for example, tried to steer the course of history through Julius Caesar and Mark Antony. But those events occurred between 47 and 30 B.C., and the Getty gold represents a much older period. We do not have to wait for the first century B.C. to encounter powerful Ptolemaic queens. A woman equipped with all the attributes of a divinity and limitless ambition—the wife of the second Ptolemy, Arsinoë II—was one of the most ambitious and ruthless personalities of the Hellenistic world.

Arsinoë II was the first in a line of powerful and often dangerous Ptolemaic queens. Daughter of Ptolemy I, she was energetic, relentless, and entirely

unscrupulous. Married as a young princess to the aging king Lysimachus of Thrace, she had him execute his popular son from a previous marriage in order to make way for her own offspring. But the royal schemer saw her dreams shattered when her elderly husband lost his kingdom and his life in the battle of Korupedion in 281 B.C. at the hands of the founder of the house of Seleucus. Arsinoë, whose royal career seemed doomed to end prematurely with her husband's death, was convinced by her half brother, Ptolemy Keraunos (lightning), to marry him. Ptolemy Keraunos, who wanted to become king of Macedon, murdered the Seleucid victor of the battle of Korupedion and then killed Arsinoë's small children in front of her.

Now queen without a kingdom, Arsinoë fled to Egypt, where she was welcomed by her full brother Ptolemy II. Not content, however, to spend the rest of her life as a guest at the Ptolemaic court, she had Ptolemy II's wife exiled to Upper Egypt and married him herself around 275 B.C. Though such an incestuous marriage was considered scandalous by the Greeks, it was allowed by Egyptian custom. For that reason the marriage split public opinion into two factions. The loyal side celebrated the couple as a return of the divine marriage of Zeus and Hera, whereas the other side did not refrain from profuse and obscene criticism. One of the most sarcastic commentators, a poet with a very sharp pen, had to flee Alexandria. The unfortunate poet was caught off the shore of Crete by the Ptolemaic navy, put in an iron basket, and drowned. This and similar actions seemingly slowed down vicious criticism. Arsinoë II had no children by this marriage, but she adopted the children of her brother's exiled first wife. Among these children was the young prince who, as Ptolemy III, would lead Egypt to the height of her political power. Although it is unlikely that he loved his stepmother, he later never disputed that Arsinoë II, and not his biological mother, was named as his mother.

On one occasion when Ptolemy II attended a theater festival, the appearance of the god and monarch was widely applauded, and he was greeted with a special vessel, a double cornucopia. This was a unique vessel that the king himself had created for Arsinoë II. The double cornucopia symbolized the blissful union of the royal couple. This image of good fortune is the very horn that we see on one of the Getty finger rings.

Carved on the oval sard is Tyche, the Greek goddess of good fortune and fate, holding in her arm Arsinoë II's attribute, the double horn of plenty [FIGURES 24a–d]. Because of the specific and historical evidence connecting Arsinoë II to the double cornucopia, its use on this ring can be directly identified with her. For that reason, the representation on the ring can then be identified with certainty as the queen herself personifying fate and plenty. Arsinoë / Tyche is casually leaning against a pillar on which she rests her left arm (the description is based on the impression of the gem; see FIGURE 24c). She stands on her right foot, her right hip protruding considerably to the left.

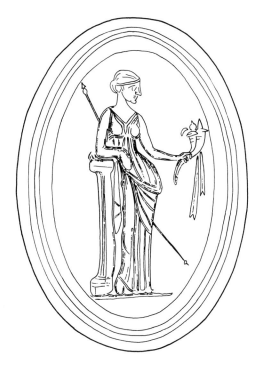

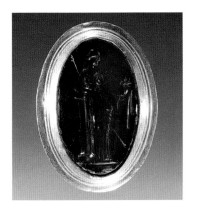 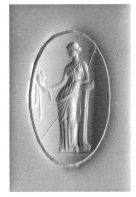

Figure 24a
Finger ring with intaglio gemstone depicting the Greek goddess Tyche. Late third–early second century B.C. Gold and sard. Length 4.5 cm (1 ¾ in.). Malibu, J. Paul Getty Museum (92.AM.8.9).

Figure 24b
Side view of finger ring, figure 24a.

Figure 24c
Impression of finger ring, figure 24a, showing Tyche.

Figure 24d
Drawing of intaglio of finger ring, figure 24a, showing an Arsinoë-like Tyche with scepter and double cornucopia. Drawing: Peggy Sanders

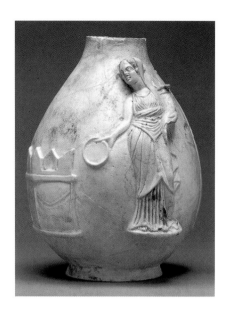

She wears a long chiton fixed on both shoulders and girded high under her breasts. A huge stafflike scepter appears to float behind her.

This finger ring is not the only representation of Arsinoë/Tyche in Ptolemaic Egypt. Tyche with the double cornucopia is represented on several Ptolemaic oinochoai, a type of jug sometimes made of Egyptian faience. The vessels usually depict Tyche standing in front of an altar and next to a pillar wound with fillets. The goddess carries a cornucopia in her left arm. The inscriptions make clear the royal connotation of the scenes by referring to the good fortune of the queens and sometimes mentioning Isis and Aphrodite, the divine merger we have already encountered. On an oinochoe in the Getty Museum, Berenike II, the wife of the third Ptolemy, is represented in her role as goddess of good fortune, but, to set her apart from her famous ancestor Arsinoë II, she is depicted with a single cornucopia [FIGURE 25]. The inscription on the altar refers to the royal couple in their capacity as divine benefactors, the *theoi euergetai*.

Long scepters usually characterize powerful deities such as Zeus. In the Hellenistic era, these scepters were widely used on the coinage of the Ptolemies to symbolize the divine status of the dynasty. We have already stressed that the Egyptian pharaoh was the living image of eternal gods, and that he was responsible for the well-being of the country. If the Nile did not fertilize the fields, the pharaoh had to open his storehouses and feed his people; he was accountable for the prosperity of the temples and for the continuity of religious activities that in turn guaranteed the very existence of the world. Thus the role of the Macedonian pharaoh was clearly defined. What is fascinating is the rising importance of the queens.

As the living Aphrodite, Arsinoë II had a well-known sanctuary on the promontory of Zephyrion close to Alexandria, which was celebrated by famous poets. The poet Poseidippos wrote about this temple that was dedicated by the admiral Kallikrates:

> Midway between the shore of Pharos and the mouth of Canopus, among the encompassing waves, my site is this wind-swept breakwater of Libya rich in sheep, facing the Italian west wind. Here Callicrates set me up and called me the shrine of Queen Arsinoe-Aphrodite. Come then, ye pure daughters of the Greeks, to her who shall be famous as Zephyritis-Aphrodite, and ye, too, toilers on the sea; for the nauarch built this shrine to be a sure harbour from all the waves. (P. M. Fraser, *Ptolemaic Alexandria*, 1: 239)

In this fine example of courtly lyric the queen functions as a goddess protecting the sea and seafarers, a very logical association since Aphrodite was born from the foam of the sea. Another temple in Alexandria was dedicated to Arsinoë as well. There were plans for an iron image of the queen to float under a magnetic ceiling inside this major temple. While this is a gross exaggeration of the actual technical capabilities of the time, it is very telling of the spirit of technical creativity and endeavor in Ptolemaic Alexandria, the city that housed the leading university of the Hellenistic world—which was funded and protected by the Ptolemies.

Arsinoë II collected divine titles. In addition to Tyche, Isis, and Aphrodite she became known, with Ptolemy II, as the "brother- and sister-loving gods" (*theoi philadelphoi*). This divine title started a Ptolemaic tradition. In the generations that followed, the reigning Ptolemies were viewed primarily as divine couples. In addition to the gods just mentioned, we encounter the "gods who love their father," the "savior gods," and the "benefactor gods" just mentioned, thus underscoring the outstanding political importance of Ptolemaic queens. We know of several queens who actually exercised power and had their own coinage, a privilege usually limited to the king.

According to inscriptions, Arsinoë II was viewed as a ruler of Upper and Lower Egypt, a title almost exclusively reserved for kings. This title referred to her as a reigning monarch and was given to only a few pharaonic queens,

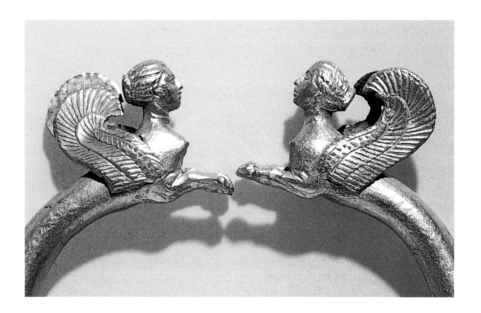

including the famous Hatshepsut (r. 1486–1468 B.C.). Placing the daughter of a Macedonian pharaoh in line with great figures of Egyptian history cannot be overlooked. A bracelet from the above-mentioned temple treasure from Toukh el-Quaramous may show a Ptolemaic queen, in all likelihood Arsinoë II, as a female sphinx [FIGURE 26]. In Egypt the sphinx symbolized the divine power of the king and as such could not be female, although in Greek mythology the sphinx was almost always considered female. Eventually, under the Ptolemies the idea of a female sphinx gained ground—no doubt due to the increasing power of their queens. Since the divine queen was viewed as a ruling monarch who was co-responsible for the well-being of her country, it was appropriate for Arsinoë II to be portrayed in art as the goddess of good fortune and fate.

Arsinoë II had also made an attempt to become the divine equivalent of Artemis, the virgin goddess of the animal world. In Egypt, this rather unusual association added a new aspect to the Ptolemaic ruler cults; it could be seen as a confirmation of a legend born long before the days of the Ptolemies. In the fifth century B.C. the author Herodotos, the father of written history, was the first to equate Greek and Egyptian gods. According to him the divine twins Artemis and Apollo were actually the children of the Egyptian Isis. In Ptolemaic times reference was made to this very special legend on Delos, the sacred island

of Apollo where Arsinoë/Isis was worshiped along with Apollo and Artemis. The Getty gold adds new support for the Artemis connection, for the second finger ring unmistakably depicts this goddess of hunting and the animal world [FIGURES 27a–d].

Like Tyche on the other ring, Artemis leans against a pillar, but her pose is far more exaggerated. The left hip protrudes notably, and her figure rests on her invisible left foot; the right leg crosses in front with its heel turned outward in an almost mannered fashion. For the virgin Artemis, this is a rather extravagant pose. She is appropriately equipped with a bow and quiver and has a deer standing next to her as a living attribute. The miniature face of Artemis is what is so unique. The huge Ptolemaic eye and

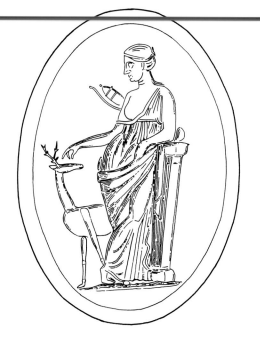

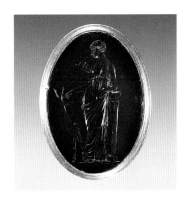

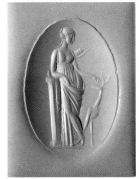

Figure 27a
Finger ring with intaglio gemstone depicting Arsinoë II as the goddess Artemis. Late third–early second century B.C. Gold with cabochon carnelian. Length 4.2 cm (1 ⅝ in.). Malibu, J. Paul Getty Museum (92.AM.8.8).

Figure 27b
Side view of finger ring, figure 27a.

Figure 27c
Impression of finger ring, figure 27a, showing Artemis.

Figure 27d
Drawing of intaglio of finger ring, figure 27a, showing Artemis with profile of Arsinoë II. Drawing: Peggy Sanders.

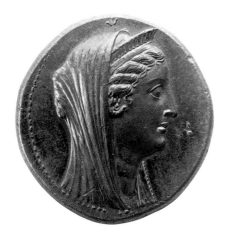

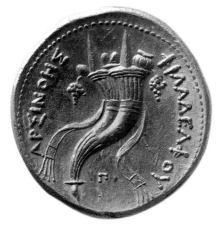

Figure 28a
Octadrachm. Obverse:
portrait of Arsinoë II.
After 270 B.C.
Gold. Athens, National
Museum, Numismatic
Collection. Photos:
Hirmer Fotoarchiv.

Figure 28b
Reverse of octadrachm,
figure 28a, with
double cornucopia.

the long pointed nose suggest that we are dealing not with an anonymous Artemis but with Queen Arsinoë II herself. The long end of a diadem flowing over her right shoulder further corroborates the royal image. The profile is similar to that on a coin of Arsinoë II [FIGURES 28a–b].

We have learned to equate Arsinoë II with Aphrodite, and consequently it is not surprising to recognize that the virgin Artemis, who in Greek belief essentially despised men, has adopted some Aphrodite-like features. Her chiton slides unmistakably from her shoulder to bare her left breast, something that would be almost unthinkable for the goddess of hunting but very appropriate for the goddess of female beauty and physical attraction. Thus, the artist has provided us with a very special and highly unusual interpretation of Artemis; with royal references and the features of Aphrodite, this interpretation results in a royal Artemis/Aphrodite/Arsinoë.

Having paved the way for the many powerful Ptolemaic queens [SEE FIGURES 19, 25, 29, 30a], Arsinoë II died unexpectedly in 270 B.C. after a turbulent life. Without her, Ptolemaic Egypt would not have been the same, and the political potential of its queens would probably not have been realized. The long-lasting influence of the demonical queen is borne out by the Getty rings. Because the style of the rings clearly shows that they were not made during her lifetime, but at least two generations later—around the end of the third or the beginning of the second century B.C.—the Getty rings are evidence of her tremendous importance for the cults of the divine queens.

The famous Decree of Canopus issued in 238 B.C. (published in at least three scripts—hieroglyphic, demotic, and Greek) instructs that royal priests should be recognized by their finger rings. What could be more appropriate

than to characterize the anonymous owner of the two Getty rings as a priestess of a Ptolemaic queen?

The iconographic connection of Artemis to the queen was not abandoned after Arsinoë II's death, as demonstrated by an event that marked the start of the Fourth Syrian War and the beginning of the reign of Arsinoë III (222 B.C.). In a very dramatic gesture, the young queen dedicated locks of her hair in a temple of Artemis, unmistakably referring to the famous dedication by her mother, Berenike II, of her hair when her husband returned safely from the Third Syrian War in 245 B.C. The story goes that the day after Berenike's legendary dedication in the temple of Arsinoë-Zephyritis the lock was missing. In an opportune moment of flattery the astronomer Konon claimed to have discovered the royal lock among the stars. (In fact, the constellation is today still known as the "Lock of Berenike.") The most famous poet of the Ptolemies, Kallimachos, hailed the event with a celebrated poem, which was later, in the days of Julius Caesar, translated into Latin by the Roman poet Catullus.

We know very little about Berenike's life at the Ptolemaic court except for vignettes such as the story of her husband playing a game of dice using knucklebones. While greatly enjoying himself, the king was handed some death sentences to approve. He made a swift decision with the knucklebones still in his hands. His wife apparently interrupted to remind him that the matter deserved his utmost attention. In spite of this picture we should not think of her as an entirely benevolent character. As a girl she arranged the assassination of an unwelcome fiancé because she wanted to marry Ptolemy III. This action was highly applauded by Catullus several centuries later. Considering these two dimensions of her character, it is not surprising to see Berenike on a mosaic in an entirely different capacity [FIGURE 29]. This mosaic was made around 200 B.C., a generation after the queen's death. It depicts her in full armor with a shield behind her back like a soldier. She is wearing a cuirass and carries a standard with long diademlike bands that float in the wind. Berenike functioned at times as a ruling monarch and issued coins on her own, but are we actually to think of her in an active military role? We know that she enjoyed horse racing, the sport of queens. She was reportedly even successful in the chariot races of the Olympic games, but one is inclined to think of her as a spectator like many

ΣΩΦΙΛΟΣ
ΕΠΟΙΕΙ

Figure 29

Reconstruction drawing of mosaic of Berenike II in military apparel with shield and standard. From Thmouls. About 200 B.C. University of Trier, Archaeological Institute, Drawing Collection. Drawing: Ulrike Denis.

members of royal families today. Was she actually able to control a chariot herself? It is possible that the life of her sister-in-law, a full sister of her husband, can offer some insight.

Berenike II's sister-in-law was also called Berenike and is known in history as Berenike Syra, because she was married in the middle of the third century B.C. to a Seleuco-Syrian king. The young queen was famous for her enormous dowry and notorious for having holy water brought from the Nile to Syria to guarantee her fertility. The water must have been successful, for the queen gave birth to a boy named Antiochos after his father. In the summer of 246 B.C. her husband died or was murdered, and a faction of the Seleucid court backed a son from an earlier marriage in his claim to the throne of Asia. This faction had to get rid of Berenike's son, Antiochos, so they kidnapped him. When the terrible news reached the young mother, she mounted a chariot and hurriedly drove it to the site of the crime. She arrived in time to see the last of the kidnappers retreating and hurled a lance after the villain. The lance missed, so she proceeded to kill him with a slingshot. Yet, despite her heroism, she could not

42

rescue her child, and the young prince was murdered a few days later. Berenike herself did not escape either; she was later assassinated.

It is thus possible that Berenike II may have driven a chariot, although in all likelihood not in Olympia. The terrible murders of her sister-in-law and nephew brought most of Seleucid Syria and Asia to the side of the Ptolemies, and Ptolemy III, the brother of the unfortunate Syrian queen, captured the Seleucid capital of Antioch without any resistance. The realm of the Ptolemies reached the peak of its power during this time, far exceeding the political achievements of even the greatest pharaohs of the Egyptian past. For one glorious but brief moment a return to the empire of Alexander the Great seemed possible. It was a woman, the heroic Berenike Syra, who was the catalyst for these events. But a dangerous rebellion back in his Egyptian homeland prevented Ptolemy III from realizing his dream.

We know only a little about Arsinoë III, Berenike II's successor. Arsinoë was the sister/wife of Ptolemy IV, whose reign began in 222 B.C. Together they were known as "the couple of the father-loving gods," *theoi philopatoroi*. Eratosthenes, one of the greatest scientists and researchers of the ancient world, wrote a biography of the queen that is now lost except for one line that highlights Arsinoë's concern for the kingdom. When suddenly faced with one of her brother's notorious drinking bouts, she turned to Eratosthenes and stated that she could see how the kingship could fall.

Arsinoë had good reason to worry, for in the later years of the third and the early years of the second century B.C. the Ptolemaic monarchy was often at risk. The time immediately after the couple's ascension to the throne was especially tense. The Seleuco-Syrian Empire used the momentary weakness of Ptolemaic power to mount a deadly attack on Egypt. The combined armies of the East met the Ptolemaic forces on the Palestinian plain of Raphia. For the first time the Ptolemies used native Egyptian soldiers trained like the Macedonian infantry, and these Egyptians played a major role in the confrontation's tactical strategy. Just before the battle, the young queen herself appeared in front of her kingdom's army to ignite the spirits of her troops—especially her Egyptian subjects, who were expected to risk their lives for a foreign dynasty. Her impact was obviously tremendous, and the soldiers hailed the young queen. At the height of the

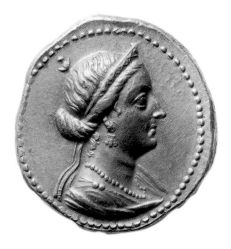

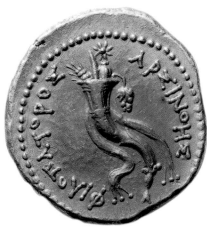

Figure 30a
Octadrachm. Obverse:
Portrait of Arsinoë III.
Late third–early second
century B.C. Gold.
London, The British
Museum, Coins
and Medals. Photos:
Hirmer Fotoarchiv.

Figure 30b
Reverse of octadrachm,
figure 30a, with
single cornucopia.

battle, the end of Ptolemaic rule seemed almost inevitable. Ultimately, however, the Ptolemaic forces were able to resist even the devastating assaults of elephants to emerge victorious and save the divine house. Posthumous gold coins were issued with the portrait of the queen wearing a band-like diadem in the fashion of a reigning king, an illustration of the exceptional esteem for the late queen [FIGURES 30a–b]. Unfortunately, like her mother, Berenike II, twenty years earlier, the father-loving goddess was assassinated after her husband's death in 204 B.C.

Late in the third century Ptolemy IV constructed a fascinating small temple, dedicated to Aphrodite, on the upper deck of his ship palace [FIGURE 31]. The tiny courtyard that housed the temple was reached by way of two sets of winding stairs that originated in the sumptuous rooms belonging to Arsinoë III, who according to court fiction was a granddaughter of Arsinoë II. The intimate temple court was surrounded by two small dining rooms filled with couches. These rooms were meant to demonstrate to exclusive guests the divine function of the queen, who like her grandmother was connected to Aphrodite. Every guest summoned to the ship palace and granted the extraordinary privilege of dining with the queen before the statue of her immortal equivalent, Aphrodite, must immediately have recognized Arsinoë III as a living goddess and ruling monarch.

Our survey of queens would be incomplete without a glance at the most famous queen of all, Kleopatra VII. She is not a product of the era of the gold jewelry; nevertheless she embodies many of the most notable aspects of the divine queens. Kleopatra VII appears almost two centuries later as the last of the living Isis-Aphrodites and incorporates Arsinoë's double horn of plenty on some of

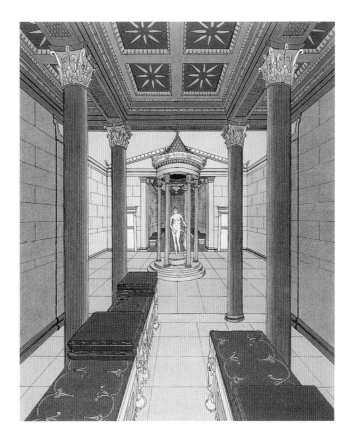

her coins. Although known in modern times primarily for her love affairs with Julius Caesar and Mark Antony, Kleopatra VII was primarily a political figure who tried to save her Ptolemaic kingdom from being overwhelmed by the Romans. With the cooperation of Mark Antony the queen attempted to regain Ptolemaic supremacy over the eastern Mediterranean. In 31 B.C. Octavian (the later emperor Augustus) crushed this dream with a devastating defeat of Mark Antony's and Kleopatra's fleet at the Battle of Actium and the subsequent and final capture of Alexandria. On the threshold of a new age Kleopatra tried the impossible and failed. Her eventual suicide the following year put an end to Egyptian independence, the house of Ptolemy, and the divine queens. These dramatic events also spelled the end of the epoch of Alexandria and the dynasty descended from Herakles. The new world belonged to the Romans.

Figure 31
Reconstruction drawing of temple of Aphrodite on upper floor of the *Thalamegos* of Ptolemy IV. Built between 222/221 and 204 B.C. University of Trier, Archaeological Institute, Drawing Collection (1997.9B). Drawing: Ulrike Denis, after a sketch by Michael Pfrommer.
© Michael Pfrommer.

RELIGION: ONE LANGUAGE
FOR TWO CIVILIZATIONS

Images associated with four gods are exquisitely combined on the Getty's elaborate hairnet—Aphrodite, Eros, Dionysos, and Herakles [SEE FIGURES 3a–b]. Aphrodite (equivalent to Isis) occupies the central medallion with Eros (equivalent to Horus) on her shoulder playfully pulling at her garment [SEE FIGURE 3c]. Crowned by a crescent-shaped stephane, Aphrodite's hair falls over her shoulders, unlike the owner of the hairnet, who would have worn her hair in a bun to be covered with this elaborate piece. The lower edge of the flexible dome is formed by a narrow band bearing a delicate wreath of ivy with a Herakles knot in the center [FIGURES 32a–b]. As in the case of the Getty stephane the Herakles knot on the hairnet, originally inlaid with garnets, is entirely ornamental. The small delicate dome of the hairnet is decorated with Dionysian theater masks, chains, and rows of spool beads [FIGURE 32c; SEE ALSO FIGURES 32f–i]. The dome was closed by two simple loops of gold wire and a pin, from which only the long tassel has survived; FIGURE 32d shows the tassel placed in its original position. Another set of dangling chains and beads are firmly attached to the hairnet just below the bust of the goddess [FIGURE 32e].

The Ptolemies saw traditional representations of deities as an opportunity to insert iconography that was identified with their dynasty. By associating themselves visually with the gods, they communicated their divine heritage to their subjects. Generations after the production of the Getty jewelry group, a humble bronze coin was minted that bore on its reverse the double horn of Arsinoë II and an inscription referring to Kleopatra VII. On its obverse was a

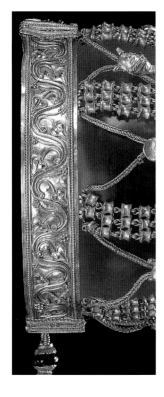

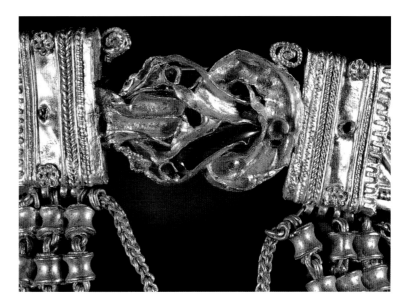

composition strikingly similar to the medallion of the hairnet: Aphrodite with a small baby and wearing a crescent-shaped stephane in her hair. In contrast to jewelry, coins were not merely allusions to royalty but also official issue that represented the political dynasty. This is underscored by the divine scepter that appears behind the shoulder of the deified queen, common on many issues of Ptolemaic coinage. Undoubtedly the coin pictured the famous queen herself along with a child, yet it adopted the iconography of Aphrodite and Eros. Only in Ptolemaic Egypt could the queen and her son be understood as Aphrodite and Eros, as well as their counterparts Isis and Horus. Building upon generations of iconography established by her forebears, Kleopatra's coin could eventually allude to the joining of Egypt and Rome.

Though it lacks specifically royal insignia, the hairnet does not lack regal allusions. The crescent-shaped stephane that crowns the goddess on the medallion is a typical feature of Ptolemaic queens, as we have discussed. When

Figure 32a
Sheet-gold band with filigreed ivy from base of hairnet, figure 3a.

Figure 32b
Herakles knot from hairnet, figure 3a; inlays missing.

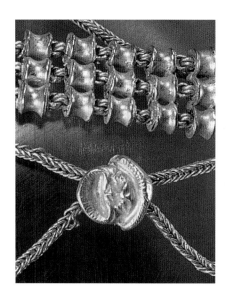

Kleopatra surrendered to Octavian in 31 B.C. she offered him her throne, scepter, and stephane as signs of her submission. Aphrodite's hair is styled in the so-called melon coiffure with separated strands of hair tightly pulled to the back of the head [CF. FIGURE 18]. This hairstyle had been especially common in portraits of Arsinoë II. In the case of the medallion, the hairstyle is combined with free-flowing hair cascading over Aphrodite's shoulders, which may be a reference to the locks of Berenike [SEE FIGURE 29]. But because the composition is lacking a royal scepter or a double cornucopia—the hallmarks of Ptolemaic iconography—we should interpret the medallion more as a reflection of dominant Ptolemaic ideologies and the religious background of its time.

Ivy forms are omnipresent both on the hairnet and on the stephane. As mentioned above, ivy was the holy plant of Dionysos and a common symbol of the god. The tiny theater masks that form the links between the diagonal gold chains commemorate him as a divine patron of actors and the theater. This interpretation would apply not only to the god but also to his living image, for the Ptolemaic kings functioned as important patrons of the theater. Ptolemy IV, who indulged in writing plays, even saw himself as a New Dionysos and had an image of an ivy leaf tattooed on his body. One of his plays, *Adonis*, focuses on the constantly dying and reborn god as a symbol of the changing seasons of the year, a very telling subject for a king who was both mortal and immortal, both human and divine. Ptolemy IV's interest in theater is apparent also in his palace ship; the theatrical allusions at the entrance are very striking and transform the palace cabin, with its sanctuaries, into a natural stage for the divine royal couple. Two of the masks on the hairnet represent the god Dionysos [FIGURE 32f] and two others picture satyrs, wild half-human,

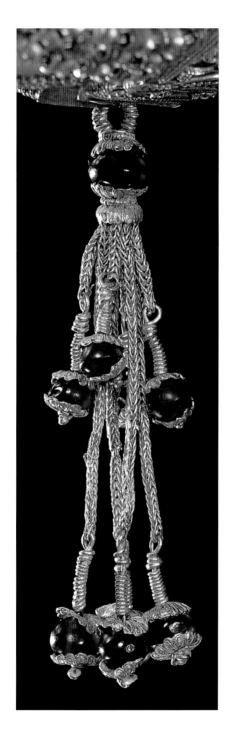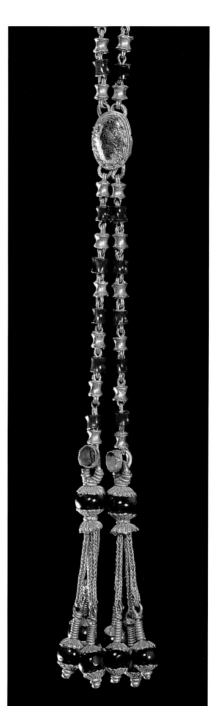

 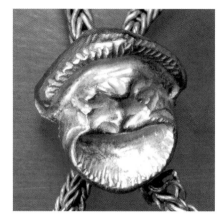

left to right
Figure 32f
One of two masks of
Dionysos linking chains
of hairnet, figure 3a.

Figure 32g
One of two masks of
satyrs linking chains of
hairnet, figure 3a.

Figure 32h
One of two masks with
silen features linking
chains of hairnet,
figure 3a.

Figure 32i
One of two masks of
hetairai, or possibly
maenads, linking chains
of hairnet, figure 3a.

half-horse creatures that formed part of the god's retinue [FIGURE 32g]. Two belong to a type of silen masks [FIGURE 32h], and the remaining two show female heads with long, parted hair and a kerchief tied with a knot on top of the head [FIGURE 32i]. Although this type resembles the *hetairai* (courtesans) of the Greeks, these female heads might even be seen as maenads, the female counterparts to the satyrs.

The interest in Greek theater should not be interpreted simply as a reflection of the personal preference of an individual king. Theater continually attracted thousands of people and was a major vehicle for mass communication and for the transmission of Greek culture. In the Hellenistic age small minorities of Greeks and Macedonians controlled remote regions such as Central Asia, entirely Oriental capitals such as Babylon, and countries more alien to Greek traditions, such as Egypt. Thus it is not surprising that excavators have discovered Greek theaters all over the Hellenistic world. Greek plays, with their roots deep in religious and mythological subjects, were an excellent platform for promoting Greek culture and for keeping Greek traditions alive. When the Macedonian Ptolemies were so enthusiastic about theater, they were actually broadcasting their heritage and their rich cultural traditions.

Today, the practice of appearing in a divine costume might seem almost childish, reminding us as it does of carnivals or Halloween, but in the ancient world, especially in Ptolemaic Egypt, it produced a very different reaction. If a king or a Roman general such as Mark Antony appeared in public as a New

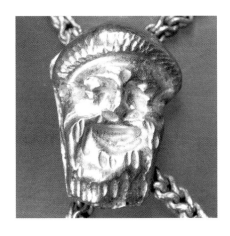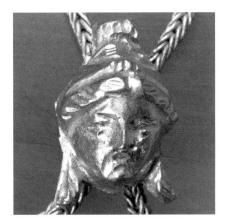

Dionysos, he assumed a new dimension. Velleius Paterculus in his *History of Rome* (2.82.2) describes how Mark Antony had "given orders that he should be called the new Father Liber [Dionysos], and indeed in a procession at Alexandria he impersonated Father Liber, his head bound with the ivy wreath, his person enveloped in the saffron robe of gold, holding in his hand the thyrsus, wearing the buskins, and riding in the Bacchic chariot" (trans. F. W. Shipley).

By the middle of the first century B.C. the political situation around the Mediterranean had changed completely from that of the third century B.C. Then the Ptolemies had been at their zenith, but by now Rome had emerged as the dominant power. Roman armies had conquered Spain, France, Greece, Macedon, Asia Minor, Syria, and even parts of northern Africa, and this mighty opponent now surrounded Ptolemaic Egypt.

After their extensive conquests, the Roman nobility engaged in bloody civil wars. In 48 B.C. Julius Caesar crushed the legions of Pompey on the Pharsalian Plain in central Greece. The defeated general headed for Egyptian soil. He had been a friend of the deceased Ptolemy XII and had backed the ascension to the throne of the latter's thirteen-year-old son Ptolemy XIII. Pompey hoped he could rely on his former friendship and loyalty, but his plan was complicated by the fact that the Ptolemaic court was fighting a war of succession between the faction backing the young Ptolemy and the one backing his twenty-year-old sister, Kleopatra. In pursuit of Pompey, Caesar arrived in Alexandria by ship. In an attempt to please the victorious Caesar, the court presented him with the head

of Pompey, his son-in-law and friend-turned-enemy. (Mercy had never been a characteristic feature of the Alexandrian court.) The gift-bearing representative seemed unsure of Caesar's reaction and addressed the arriving general with cynical words: "You must find a name for this great deed; or else ask what the world says of it. If crime it be, then you admit a greater debt to us, because your own hand is not guilty of the crime" (Lucanus *The Civil War* 9.1029ff., trans. J. D. Duff). Caesar, very much taken aback by the opportunistic murder, nevertheless took up quarters at Alexandria.

The late king had dictated that his son Ptolemy XIII and his daughter Kleopatra VII should rule together as legitimate joint monarchs, but he had named none other than the Roman people as administrators of his will. Caesar therefore had every right to interfere in Egypt's internal affairs. In addition, Ptolemy XII was still indebted to Caesar at the time of his death, and consequently the Roman dictator claimed no less than ten million denarii upon his arrival. He then officially summoned the competing children to his tribunal to arrange succession. Kleopatra, who had been banned from Alexandria by her brother, managed to reach the palace wrapped in a sheet. This highly intelligent princess and living goddess, who spoke at least eight languages and was the first Ptolemy to learn Egyptian, immediately caught the eye of the 52-year-old womanizing Roman.

In theory, Caesar's decision about the succession was wise and followed the testament of the late king. Kleopatra and her brother were to ascend the Egyptian throne as a divine couple, *theoi philopatoroi*, a second pair of father-loving gods. The court, however, was strongly opposed to the ascension of the much-hated princess, and within days the Alexandrian War was in full swing. Caesar transformed his palace quarters into a fortress. Much of the Ptolemaic fleet was burned, and four hundred thousand book scrolls in the Alexandria library were destroyed—a disastrous loss for culture and civilization. Caesar himself was almost killed in the harbor of Alexandria; he escaped only by leaving behind his purple mantle, a symbol of his rank. Caesar and Kleopatra's soldiers were constantly under siege, and it was not until the next year that they finally received succor. The young Ptolemy XIII ultimately lost his life in a tributary of the Nile. Caesar had the natural flow of the Nile diverted to retrieve his body in order to show it to the hostile but nevertheless defeated opposing side.

Later in the year 47 B.C. Caesar joined Kleopatra on a ceremonial journey up the Nile that took the couple almost to Nubia. The cabin boat was described as a *nave talamego*, the name previously used for the ship palace of Ptolemy IV. On June 23, 47 B.C., the young queen gave birth to a boy whom Caesar officially recognized as his son. Under Roman law this was irrelevant because the son of a non-Roman woman could not obtain the rights of a Roman citizen. For Kleopatra, however, Caesar's recognition was priceless because it meant that none other than Caesar's son would rule Egypt, and who but the son of Julius Caesar could save the Ptolemies from extinction and guarantee the independence of the monarchy in an otherwise entirely Roman world? Thus the name of the prince was very telling: *Ptolemaios Kaisar*, the Greek form of Caesar, although in ancient history the boy was primarily known by his Alexandrian nickname, Caesarion (little Caesar).

Kleopatra must have felt on top of the world in 47 B.C. She visited Caesar in Rome—a scandalous event in the eyes of the conservative members of the Roman nobility. But in 44 B.C. her plans were shattered when Caesar's life ended by the daggers of his friends-turned-enemies. One of Caesar's former generals, his adopted son Octavian, finally brought this murderous faction down in the Battle of Philippi, but the fulfillment of Kleopatra's dreams seemed far away. In 41 B.C. the queen, more a vassal of the Romans during this time, was summoned to the court of Mark Antony in Tarsos in southern Turkey. Her appearance was celebrated with all the theatrical bombast Ptolemaic Egypt could produce. In the eyes of her contemporaries, the living Aphrodite had come to visit the New Dionysos, a perception that raised the event to an almost mystical level. According to the historian Plutarch, the queen arrived on a golden ship dressed as Aphrodite:

> Though she received many letters of summons both from Antony himself and from his friends, she so despised and laughed the man to scorn as to sail up the river Cydnus in a barge with gilded poop, its sails spread purple, its rowers urging it on with silver oars to the sound of the flute blended with pipes and lutes. She herself reclined beneath a canopy spangled with gold, adorned like Venus in a painting, while boys like Loves in paintings stood on either side and fanned her. Likewise also the fairest of her serving-maidens, attired like Nereïds and Graces, were

stationed, some at the rudder-sweeps, and others at the reefing-ropes. Wondrous odours from the countless incense-offerings diffused themselves along the river-banks. (Plutarch *Antony* 26.1–2; trans. B. Perrin)

As it had been with Caesar, Kleopatra's strategy was well chosen; the Roman *imperator* (general) fell for her almost immediately, and in time he fathered two princes and a princess by her, all named to commemorate the rise of the new Ptolemaic dynasty. (It is worth noting that Caesar's son, Caesarion, always ranked above the children of Mark Antony.)

Although Kleopatra emerged brilliantly in Tarsos as the living Aphrodite, in Egypt she was primarily worshiped as the New Isis [FIGURE 33]. The following epic lines addressed to Isis illustrate the importance of the Egyptian goddess even to a Greek in the late Hellenistic period:

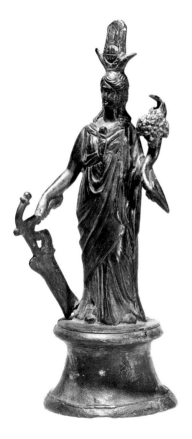

I am Isis, the Mistress of Every Land, and I was taught by Hermes, and with Hermes I devised Letters, both the Sacred and the Demotic, so that all things might be written with the same letters. I gave and ordained Laws for men, which no one is able to change. . . . I am the queen of war. I am the queen of thunderbolt. I stir up the sea and I calm it. I am the rays of the sun. Whatever I please shall come to an end, it shall end. With me, everything is reasonable. I set free those in bonds. I am the queen of seamanship. I make the navigable unnavigable when it pleases me. I created walls of cities. I am called the lawgiver. I brought up islands out of the depths into the light. I am lord of rainstorms. I overcome fate. Fate hearkens to me. Hail, Egypt that nourished me! (M. Grant, *Cleopatra* [New York 1972], pp. 119–20; trans. J. Lindsay)

Figure 33
Statue of Isis with cornucopia and pharaonic attributes. Late Hellenistic. Bronze. Height 19 cm (7½ in.). Malibu, J. Paul Getty Museum (71.AB.180).

As the New Isis, Kleopatra was no less than the creator of mankind and civilization. Her suicide in 30 B.C. marked not only the downfall of Mark Antony; as mentioned above, it also marked the end of Ptolemaic rule in Egypt. In fact, in Ptolemaic eyes, it marked the end of the world.

In a famous now-lost inscription found in the sixth century A.D. at Adulis (modern Suakin) on the western shore of the Red Sea, Ptolemy III revealed his divine ancestors and the vastness of his realm:

> The great king Ptolemy, son of king Ptolemy and queen Arsinoe, Brother Gods, children of king Ptolemy and queen Berenike, Saviour Gods, the descendant on the father's side from Herakles, son of Zeus, on his mother's from Dionysus, son of Zeus, having inherited from his father the royalty of Egypt and Libya and Syria and Phœnicia and Cyprus and Lycia and Caria and the Cyclades, set out on a campaign into Asia with infantry and cavalry forces and a naval armament and elephants both Troglodyte and Ethiopic, which his father and he himself first captured from these places, and, bringing them to Egypt, trained them to military use. (J. P. Mahaffy, *A History of Egypt*, vol. 4, *Under the Ptolemaic Dynasty* [London 1899], 105–106)

According to Ptolemaic court fiction, Ptolemy III conquered all Asia during the so-called Third Syrian War, his Asian campaign. He was heralded as the second Alexander the Great.

The Ptolemaic pharaohs were embodiments of Osiris and Dionysos (among others); they were mortal rulers dealing with two complex cultures. The blending of these cultures produced a mixture of symbols. As a form of language—in either religious or dynastic contexts—this symbolism could easily be understood in Ptolemaic Egypt by both Greeks and Egyptians.

There was an additional dimension to this god-pharaoh blend that became increasingly important to the Ptolemies: empire. According to an early Ptolemaic legend, the Egyptian god Osiris once traveled to India and civilized that country. On his return to Egypt he passed through northern Greece and placed Makedonos on the throne of Macedon. The combination of Egyptian religion and the mythical descent of Macedonian Ptolemies is striking. But this

is not the end of the story. Several thousand years later Dionysos reportedly conquered India, and several thousand years after that Alexander the Great actually reached the subcontinent during his Asian campaigns. Ptolemaic court fiction held that Alexander was the half brother of the first Ptolemy. Therefore the Ptolemaic line—inheriting the legacy of empire-building from both their divine and their royal ancestors—could lay claim to ruling all Asia. This claim was not only kept alive by Ptolemy III, as seen in the above-quoted inscription of Adulis, but it was repeated throughout Ptolemaic history, especially in connection with Ptolemy VI.

At the end of the Ptolemaic dynasty Mark Antony and Kleopatra VII were motivated by this ambitious notion as well. When Kleopatra met Mark Antony in Tarsos, she arrived as Aphrodite-Isis to join Dionysos-Osiris. That choice of gods was part of a scheme to rule Asia and restore the era of Alexander the Great. A Ptolemaic-Roman future should rival a glorious past. The dynastic gods involved were precisely the deities used two hundred years earlier by Ptolemy III to convey almost identical political ambitions.

On the Getty hairnet this symbolism was used to demonstrate the loyalty and the Ptolemaic affinities of its owner. This correspondence between the iconography of the hairnet and Ptolemaic ideology is more stunning when it is compared to a golden hairnet of very similar technique and alleged Egyptian provenance now in New York [FIGURE 34]. The construction, with its spool-like elements, is very similar to that of the Getty hairnet; the New York piece also originally had a pendant like the Getty's. The medallion pictures the head of a maenad, a female companion of the satyrs who joined the wild entourage of Dionysos. Maenads are often represented in exuberant dances with musical instruments or with knives and parts of torn animals, and even dismembered children. Dangerous and almost uncontrollable, they were nevertheless the primary sexual targets of the satyrs, who were driven by their animal instincts. Although the New York hairnet includes this Dionysian reference so essential to the Ptolemaic court, there is no image of Aphrodite or Eros and no reference to Herakles. That does not mean, however, that the original owner of the maenad hairnet was not a member of the Ptolemaic court. If we take into consideration that the ruling Ptolemy was a New Dionysos, it would have been most appro-

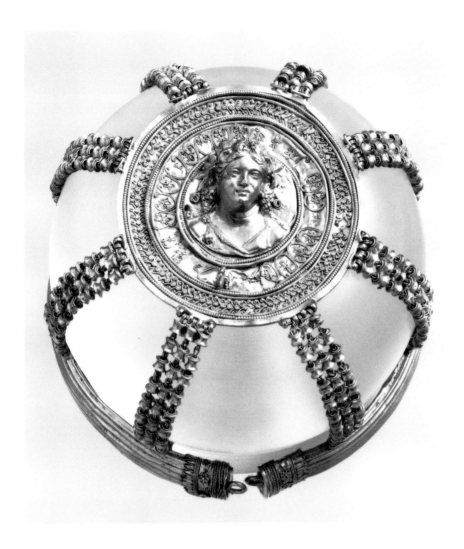

priate for some of his maids of honor to carry or wear images of maenads. However, when we place the maenad medallion in the context of the Alexandrian court, the complex symbolism of its Getty counterpart is even more remarkable. With references to Dionysos and the theater, to Herakles and, above all, to Aphrodite and Eros, the anonymous owner of the Getty hairnet and her goldsmith paid brilliant tribute in a most elegant way to the central aspects of the Ptolemaic ruler cults.

Figure 34

Hairnet with medallion with maenad. Perhaps from Alexandria. About 150 B.C. Gold. Diameter 9 cm (3½ in.); diameter of medallion 5.5 cm (2⅛ in.). New York, The Metropolitan Museum of Art, gift of Norbert Schimmel, 1987 (1987.220).

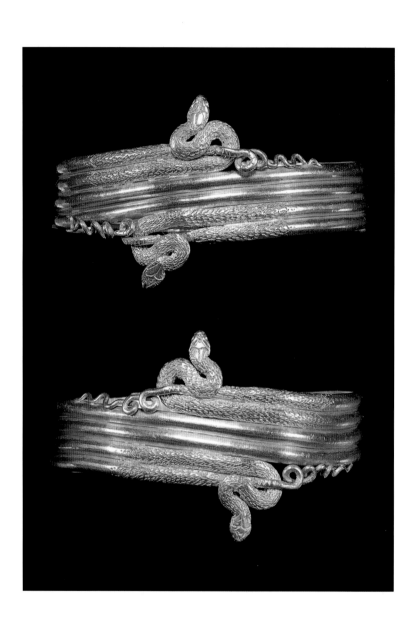

At the Brink of Disaster:
The Golden Treasure
in Its Historical Perspective

Rich with symbolism, the Getty hairnet has a lot to say about the status of its former owner. Intended neither for a small statuette nor for an over-life-sized cult statue of a goddess or queen, the jewelry must have been worn by an adult. Even if we were to consider a statue of human proportions, we must accept the probability that the mixed iconographies and pieces such as the finger rings or the cowrie shells speak strongly against such a theory. This splendid jewelry exists as a proud symbol of social status. The gold was made for jubilant events and solemn processions on the occasion of dynastic festivities.

There can hardly be any doubt that the owner of the jewelry must have belonged in the circle of Ptolemaic nobility that was so closely linked with the Alexandrian court. Since Ptolemaic officials and priests functioned in many parts of Ptolemaic Egypt, they were not necessarily linked with Alexandria. Places like the old pharaonic capital of Memphis or the city of Ptolemais in Upper Egypt become possible provenances, since we have evidence from Ptolemais of royal temples and the cults of the divine queens. Because of the absence of royal insignia such as the holy Egyptian cobra, it is unlikely that the jewelry once belonged to a queen. The snake bracelets could not have been for royalty [FIGURES 35a–c], for royalty was always symbolized by the aggressive cobra with a fanned hood, the uraeus. The same holds true for the little chain of cowrie

Figure 35a
Pair of matching bracelets each with two coiled snakes facing in opposite directions. Hellenistic (probably late third–early second century B.C.). Gold. Diameter 6.9 × 6.6 cm (2¾ × 2⅝ in.) and 6.8 × 6.7 cm (2⅝ × 2⅝ in.). Malibu, J. Paul Getty Museum (92.AM.8.7).

59

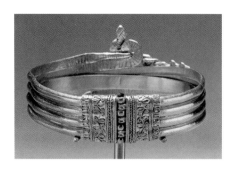

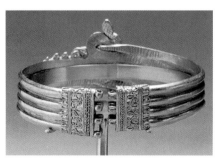

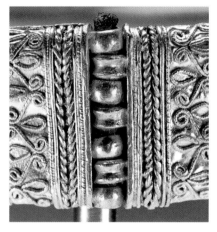

shells, which similarly includes no royal references [FIGURE 36]. A comparable chain of gold shells was discovered in the previously mentioned treasure of Toukh el-Quaramous, possibly reinforcing an Egyptian background for the Getty treasure.

The jewelry was undoubtedly the property of an upper-class lady with court connections. We have already suggested that a lady connected with the cult of queens who executed priestly functions may once have used the stephane and the finger rings. The owner could even have been one of the so-called relatives of the king, a circle formed primarily by the children and illegitimate offspring of the royal family. However, it was also possible to become a relative as a sign of honor. The wealth of the royal entourage, especially in the early Ptolemaic period, was tremendous. Along with their wealth, the royal relatives and the friends of the king were also powerful and dangerous. When Ptolemy V decided in the early second century B.C. to confiscate money in order to finance his Syrian war, he was quickly put to death.

The Getty treasure certainly reflects the wealth and ideologies of the Ptolemaic nobility but, interestingly enough, not all of the jewelry types popu-

lar in this period are represented in the assemblage. Most striking is the absence of necklaces terminating in tiny animal-heads, a most fashionable type of Hellenistic jewelry that is illustrated in the mosaic of Berenike II [SEE FIGURE 29]. The colorful beads of semiprecious stones of the Getty strand are no substitute for these necklaces [FIGURE 37]. It seems that the assemblage is not complete, and that some pieces either were not found or were separated from the hoard after its discovery. One tiny item that is missing is the pin that was essential for closing the hairnet and holding it in place; only the pin's tassel survives. On the other hand, the asemblage includes three sets of earrings and four snake armlets/bracelets, a number that clearly speaks against a tomb group, which usually contains only one set of jewelry. Given the apparent integrity of the collection—and we have no proof to the contrary—it is most probably not a tomb group but is much more likely to have been stored in the jewelry box of a Ptolemaic lady.

Because nobody hides jewelry without a reason, this treasure was most likely concealed under the threat of imminent danger. We can conjure up any number of dramatic scenarios and imagine such historical events as war, chaos, plunder, or murder. The years in question were full of such tragedies.

Life at the Ptolemaic court was far from peaceful, as illustrated by the above-mentioned fate of Ptolemy V. The destruction of the royal house was a very real prospect, and the danger did not always come from a foreign aggressor. It was the nobility, the closest friends and officials of the royal family, who tried to end the dynasty in the late third century B.C. In that century the dynasty of the Ptolemies was at the pinnacle of its power and had been ruled by three consecutive kings of exceptional abilities. But the fourth Ptolemy (r. 222/221–204 B.C.) developed into a religious fanatic who was, after his initial victory at Raphia, far more interested in his role as a living Dionysos and in his lavish image, as demonstrated by his ship palace, than in ruling an empire. Political control began to pass into the hands of powerful and entirely unscrupulous ministers such as the famous Sosibios. Immediately after the king's death in 204 B.C. the inevitable occurred. The highly respected queen Arsinoë III was put to death, and the revolutionaries presented the urns with the couple's ashes to the public. For Macedonians the practice of cremation was nothing extraordinary, but for native Egyptians it was unthinkable: Not only would the cremated royal couple never enjoy an afterlife, but they would never be able to

perform their eternal duties in the afterworld. The cremations were intended to signal the end of the dynasty in a most calculated and blasphemous manner. Worse yet, when the urn of the beloved queen was opened, it contained only spices and no human remains; her body was never found. (The murdered queen would get her revenge, as we shall see.)

In a stroke of luck for the dynasty, the driving force behind the revolt, the ominous Sosibios, unexpectedly died, and power passed through several hands. The ambitions of his followers were all too obvious. One of the most enthusiastic of these even had the portrait of a new ruler engraved on his finger ring to demonstrate his submission to and acceptance of a new sovereign. This incident confirms the importance of the Getty finger rings in light of the Decree of Canopus, which stressed that royal priests and priestesses should be recognized by their rings. There is no doubt that the Getty rings were made to distinguish their owner and to underscore her loyalty to the house of Ptolemy and its divine kings and queens.

These ambitious usurpers of Ptolemaic power had made a fateful mistake, however. For some reason they had spared the life of the crown prince, a boy of eight, thereby giving the Macedonian guard, whose job it was to guarantee the safety of the prince, a chance for intervention. The guard dragged the usurpers to the stadium in Alexandria and presented them, along with their families, to a crowd already in feverish unrest. When the young prince signaled his permission, they were cruelly put to death—tortured and pierced with spears, practically quartered. In the wake of these events, in the year 203 B.C., several women who had been raised and educated with the late queen rushed to the house of her assassin. They killed the murderer with clubs and stones, strangled his son who was still a boy, and dragged his naked wife into the street and killed her on the spot. It seems that the beloved queen had triumphed even after her death: more importantly, however, the divine house had been saved once again. The guardians of the child prince issued splendid coins with the diademed portrait of the late Arsinoë III, hailing her importance and paying tribute to the dynasty and its continuity [SEE FIGURE 30a].

The dangers for the Ptolemies were far from over. A period of chaos followed. Considerable parts of the country were entirely beyond Ptolemaic control, especially in Upper Egypt around the old center of Thebes. From the

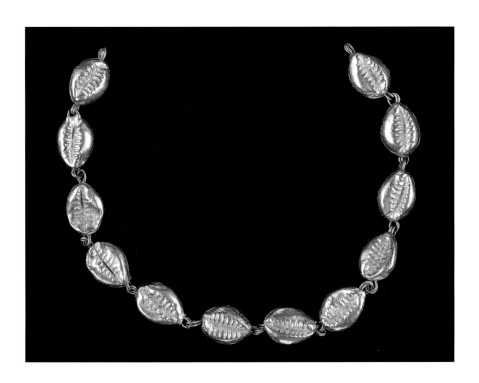

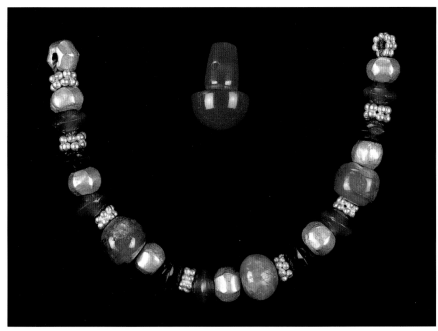

Figure 36
Hollow cowrie-shell beads. Probably Hellenistic. Gold. Length of each bead 1.0 cm (³⁄₈ in.); total length 12.2 cm (4³⁄₄ in.). Malibu, J. Paul Getty Museum (92.AM.8.11).

Figure 37
Modern arrangement of beads, perhaps from necklace; drilled carnelian. Probably Hellenistic. Gold beads, multi-colored gems, carnelian. Length of drilled carnelian 1.9 cm (³⁄₄ in.). Malibu, J. Paul Getty Museum (92.AM.8.10).

second century B.C. we know the names of native pharaohs who were backed by the powerful Theban priesthood, which competed with the most influential priests of the old capital, Memphis. More unsettling still, in 169 B.C. and again in the subsequent year, the Seleucid king Antiochos IV was able to invade and eventually conquer Lower Egypt. He may even have been crowned in Memphis as a legitimate pharaoh—just as Alexander and the Ptolemies had been. He laid siege to Alexandria, and without Roman intervention the city would not have survived.

In July 168 B.C., immediately after Rome's decisive victory over Macedon, a Roman senator appeared in Eleusis, a suburb of Alexandria and the headquarters of the Seleucid king. Antiochos, who had once been a hostage in Rome, stretched out his hand to greet his Roman friend. The senator refused his greeting and instead presented him with the decision of the Roman senate that made it clear that Antiochos had to end his imperial exploits and leave Egypt immediately. He circled the stunned king with a line in the dirt and forced him to give the necessary orders on the spot—clearly highlighting in a most humiliating way the decline of the Hellenistic monarchies. Egyptian independence continued for the generations to come, but only at the mercy of the Romans.

These events must be seen as the historical backdrop for the disappearance of the Getty treasure. Perhaps it was hidden in the wake of the assassination of Arsinoë III. Although the identity of the anonymous owner has faded into history, the drama of her final days cannot be in doubt. In grave danger and knowing that her life might be at stake, she hid her gold, and thus saved the images of her gods and the symbols of her status. Perhaps she planned to collect her treasure the next morning or the next week, but she was never to return.

BIBLIOGRAPHY

ABBREVIATIONS

Fraser, *Alexandria*
 P. M. Fraser, *Ptolemaic Alexandria*, 3 vols.
 (Oxford 1972).

Grimm, *Alexandria*
 G. Grimm, *Alexandria: Die erste Königsstadt der helleni-
 stischen Welt*, Sonderhefte der antiken Welt = Zaberns
 Bildbände zur Archäologie (Mainz 1998).

Pfrommer, *Alexandria*
 M. Pfrommer, *Alexandria: Im Schatten der Pyramiden*,
 Sonderhefte der antiken Welt = Zaberns Bildbände
 zur Archäologie (Mainz 1999).

Pfrommer, *Boscoreale*
 M. Pfrommer, *Göttliche Fürsten in Boscoreale: Der
 Festsaal in der Villa des P. Fannius Synistor*, 12. Trierer
 Winckelmannsprogramm, 1992 (Mainz 1993).

Pfrommer, *Goldschmuck*
 M. Pfrommer, *Untersuchungen zur Chronologie früh-
 und hochhellenistischen Goldschmucks*, Istanbuler For-
 schungen, vol. 37 (Tübingen 1990).

Pfrommer, *Studia Varia*
 M. Pfrommer, "Hellenistisches Gold und ptole-
 maische Herrscher," *Studia Varia from the J. Paul Getty
 Museum* 2, Occasional Papers on Antiquities, vol. 10
 (Los Angeles 2001), pp. 79–114.

For a detailed commentary on the Getty gold jewelry,
see Pfrommer, *Studia Varia*.

GREEK JEWELRY IN GENERAL
H. Hoffmann and P. F. Davidson. *Greek Gold: Jewelry
from the Age of Alexander* (Brooklyn 1965).—M. De Juliis,
ed., *Gli ori di Taranto in età ellenistica*, exh., Milan (Milan
1984).—B. Deppert-Lippitz, *Griechischer Goldschmuck*
(Mainz 1985).—Pfrommer, *Goldschmuck.*—E. Formigli
and W.-D. Heilmeyer, *Tarentiner Goldschmuck in Berlin*,
Winckelmannsprogramm der Archäologischen Gesell-
schaft zu Berlin, vol. 130/131 (Berlin 1990).—D. Wil-
liams and J. Ogden, *Greek Gold: Jewellery of the Classical
World*, exh., London (London 1994).—D. Williams, ed.,
The Art of the Greek Goldsmith (London 1998).

ALEXANDER THE GREAT:
A NEW GOD IN EGYPT

ALEXANDER THE GREAT
H. Berve, *Das Alexanderreich auf prosopographischer
Grundlage*, 2 vols. (Munich 1926).—W. W. Tarn,
Alexander the Great, 2 vols. (Cambridge 1948).—
*Alexandre le Grand: Image et réalité: Sept exposées suivis de
discussions*, Colloquium, Vandoeuvres-Geneva,
August 1975, Entretiens sur l'Antiquité Classique 22
(Geneva 1976).—P. Green, *Alexander of Macedon,
356–323 B.C.: A Historical Biography* (Berkeley 1991).—
A. B. Bosworth, *Alexander and the East: The Tragedy of
Triumph* (Oxford 1996).

ARCHAEOLOGICAL EVIDENCE
The Search for Alexander: An Exhibition (Boston 1980).—
A. Stewart, *Faces of Power: Alexander's Image and Hellenistic
Politics* (Berkeley 1993).—J. Carlsen et al., eds.,
Alexander the Great: Reality and Myth, Analecta Romana
Instituti Danici, Supplementum 20 (Rome 1993).
—*Alessandro Magno: Storia e mito*, exh., Rome (Milan
1995).—M. Pfrommer, *Untersuchungen zur Chronologie
und Komposition des Alexandermosaiks auf antiquarischer*

Grundlage, Aegyptiaca Treverensia, vol. 8 (Mainz 1998).—Idem, *Alexander: Auf den Spuren eines Mythos* (forthcoming, Mainz).

THE ROMANTIC AND NOVELISTIC TRADITION OF ALEXANDER IN THE MIDDLE AGES

Alexander the Great in the Middle Ages: Ten Studies on the Last Days of Alexander in Literary and Historical Writing, Symposium, Nijmegen (Nijmegen 1978).—D. J. A. Ross, *Alexander Historiatus: A Guide to Medieval Illustrated Alexander Literature*, Beiträge zur Klassischen Philologie 187 (Frankfurt 1988).—Idem, *Studies in the Alexander Romance* (London 1985).

THE HELLENISTIC WORLD

J. G. Droysen, *Geschichte des Hellenismus*, 3 vols. (1952; reprint, Munich, 1980).—E. Will, *Histoire politique du monde hellénistique* (Nancy 1979/1982).—P. Green, *Alexander to Actium: An Essay on the Historical Evolution of the Hellenistic Age* (Berkeley 1990).—H.-J. Gehrke, *Geschichte des Hellenismus* (Munich 1990).—F.W. Walbank, *The Hellenistic World,* rev. edn. (Cambridge, Mass., 1993).—B. Funck, ed., *Hellenismus: Beträge zur Erforschung von Akkulturation und politischer Ordnung in den Staaten des hellenistischen Zeitalters*, Akten des internationalen Hellenismus-Kolloquiums, Berlin, March 1994 (Tübingen 1996).

THE DEIFICATION OF ALEXANDER

J. Seibert, *Alexander der Große* [4] (Darmstadt 1994), pp. 192ff., with bib.

MACEDONIANS AND GREEKS

A. V. Daskalakes, *The Hellenism of the Ancient Macedonians* (Thessaloniki 1965).—A. J. Heisserer, *Alexander the Great and the Greeks: The Epigraphic Evidence* (Norman, Oklahoma, 1980).—E. Badian, "Greeks and Macedonians," in *Macedonia and Greece in Late Classical and Early Hellenistic Times*, ed. B. Barr-Sharrar and E. N. Borza, Studies in the History of Art, vol. 10 (Washington, D.C., 1982), pp. 33–51.—R. Ginouvès, ed., *Macedonia: From Philip II to the Roman Conquest* (Princeton 1994).

THE ACHAEMENIDS

H. Sancisi-Weerdenburg et al., eds., *Achaemenid History*, 8 vols. (Leiden 1987–1996).—W. J. Vogelsang, *The Rise and Organisation of the Achaemenid Empire: The Eastern Iranian Evidence* (Leiden 1992).—U. Weber and J. Wiesehöfer, *Das Reich der Achaimeniden: Eine Bibliographie*, 15. Ergänzungsband, Archäologische Mitteilungen aus Iran (Berlin 1996).

THE HELLENIZED EAST

D. Schlumberger, *L'Orient hellénisé: L'art grec et ses hésitiers dans l'Asie non Méditerranéenne* (Paris 1970).—W. W. Tarn, *The Greeks in Bactria and India* [3], introduction by F. L. Holt (Chicago 1985).—A. Kuhrt and S. Sherwin-White, *Hellenism and the East: The Interaction of Greek and non-Greek Civilizations after Alexander's Conquest* (Berkeley 1987).

PHILIP II

M. B. Hatzopoulos and L. D. Loukopoulos, eds., *Philip of Macedon* (Athens 1980).—*The World of Philip and Alexander: A Symposium on Greek Life and Times* (Philadelphia 1990).

PTOLEMAIOS I AND THE PTOLEMIES

E. R. Bevan, *The House of Ptolemy: A History of Egypt under the Ptolemaic Dynasty* (1968; Chicago 1985).—R. S. Bagnall, *The Administration of the Ptolemaic Possessions outside Egypt* (Leiden 1976).—E. Van 't Dack et al., eds., *Egypt and the Hellenistic World*, Proceedings of the International Colloquium, Louvain, May 1982 = Studia Hellenistica, vol. 27 (Louvain 1983).—A. K. Bowman, *Egypt after the Pharaohs, 332 B.C.–A.D. 642, from Alexander to the Arab Conquest* (London 1986).—W. M. Ellis, *Ptolemy of Egypt* (London 1994).—G. Hölbl, *A History of the Ptolemaic Empire*, trans. T. Saavedra (London 2000).—M. Minas, *Die hieroglyphischen Ahnenreihen der ptolemaischen Könige.* Aegyptiaca Treverensia, vol. 9 (Mainz 2000).

PORTRAITS OF THE PTOLEMIES

H. Kyrieleis, *Bildnisse der Ptolemäer*, Archäologische Forschungen, vol. 2 (Berlin 1975).

66

ALEXANDRIA, A NEW CITY IN AN OLD WORLD

SERAPIS
Grimm, *Alexandria*, pp. 81–83.

VARIOUS ASPECTS OF ALEXANDRIA
Fraser, *Alexandria.*—*Alexandria and Alexandrianism*, Papers Delivered at a Symposium, 1993, J. Paul Getty Museum (Malibu 1996).—Grimm, *Alexandria.*—Pfrommer, *Alexandria.*—F. Goddio et al., *Alexandrie: Les quartiers royaux submergés* (London 1998).—J.-Y. Empereur, *Alexandria Rediscovered* (New York 1998).

THE LIGHTHOUSE OF ALEXANDRIA
H. Thiersch, *Pharos, Antike, Islam und Occident: Ein Beitrag zur Architekturgeschichte* (Leipzig and Berlin 1909).—Pfrommer, *Alexandria*, pp. 11–16, with bib.

HERAKLES AND DIONYSOS AS PTOLEMAIC ANCESTORS OF ALEXANDER
Fraser, *Alexandria*, 1: 44–45, 202–3.—U. Huttner, *Die politische Rolle der Heraklesgestalt im griechischen Herrschertum*, Historia, Einzelschriften, vol. 112 (Stuttgart 1997).

THE HERACLEAN DESCENT OF THE MACEDONIANS
N. G. L. Hammond, *A History of Macedonia* (Oxford 1979), 2: 3–4, 13, 16–17.

THE DIADEM
H.-W. Ritter, *Diadem und Königsherrschaft* (Munich 1965).

BOSCOREALE
Pfrommer, *Boscoreale.*—Pfrommer, *Alexandria*, pp. 91–92, figs. 119–28.

THE TREASURE FROM TOUKH EL-QUARAMOUS
Pfrommer, *Goldschmuck*, pp. 208–9, FK 6.

THE FEMALE SPHINX
Pfrommer, *Alexandria*, pp. 40–43, figs. 47–48, 74–76.

PTOLEMAIC PRIESTHOODS
Fraser, *Alexandria*, 1: 214–26.—J. Quaegebeur, "Cleopatra VII and the Cults of the Ptolemaic Queens," in *Cleopatra's Egypt: Age of the Ptolemies*, exh., Brooklyn (Mainz 1988), pp. 41–54.—W. Huß, *Der makedonische König und die ägyptischen Priester*, Historia, Einzelschriften, vol. 85 (Stuttgart 1994).—H. Melaerts, ed., *Le culte du souverain dans l'Égypte ptolémaïque au III^e siècle avant notre ère*, Studia Hellenistica, vol. 34 (Leuven 1998).

THE GOD OF LOVE AS KING OF EGYPT

ISIS, APHRODITE, EROS, AND HORUS
Pfrommer, *Studia Varia.*

EROS WITH A TORCH
A. Hermary, H. Cassimatis, and R. Vollkommer, in *Lexicon iconographicum mythologiae classicae* (Zurich 1986), 3: 881–82, nos. 366–87, pls. 628–29.—N. Blanc and F. Gury, ibid., pp. 974–77, 1047, nos. 146–71, pls. 688–90.—Pfrommer, *Studia Varia.*

IO IN ALEXANDRIA
B. Freyer-Schauenburg, *Römische Mitteilungen* 90 (1983): 35–49.—G. Grimm, in *Das antike Rom und der Osten*, Festschrift Klaus Parlasca, ed. C. Börker and M. Donderer (Erlangen 1990), pp. 33–44.—M. Hamiaux, "Une reine démasquée au Musée du Louvre," *Revue Archéologique*, 1996, pp. 145–59 (Arsinoë II as Io).—Pfrommer, *Alexandria*, pp. 32–34 (Io and Epaphos).

PEARLS IN ANTIQUITY
J. Ogden, *Jewellery Studies* 7 (1996): 37ff.—Pfrommer, *Studia Varia.*

HELLENISTIC PALACES IN GENERAL
V. Heermann, *Studien zur makedonischen Palastarchitektur* (Berlin 1986).—W. Hoepfner and G. Brands, eds., *Basileia: Die Paläste der hellenistischen Könige*, Internationales symposium, Berlin 1992 (Mainz 1996).—I. Nielsen, *Hellenistic Palaces: Tradition and Renewal* (Aarhus 1994).—FOR PTOLEMAIC PALACES: Pfrommer, *Alexandria*, pp. 69–77, 93–124.—FOR THE

GREEK HOUSE: G. Husson, *Oikia: Le vocabulaire de la maison privée en Égypte d'après les papyrus grecs* (Paris 1983).—W. Hoepfner and E.-L. Schwandner, *Haus und Stadt im klassischen Griechenland*[2], Wohnen in der klassischen Polis, vol. 1 (Munich 1994).

THE THALAMEGOS
See the ancient text by Kallixeinos from Rhodes preserved by Athenaios 5.204d–206c.—FOR THE RECONSTRUCTION: Pfrommer, *Alexandria*, pp. 93–124, figs. 4, 128–130, 142, 148, 157.—THE TEMPLE OF APHRODITE: Ibid., pp. 108–12.

MOSAICS FROM ALEXANDRIA
W. A. Daszewski, in *La mosaïque gréco-romaine*, vol. 7, Actes du VIII Colloque International pour l'étude de la mosaïque antique, Lausanne, October 1997 (forthcoming).—Grimm, *Alexandria*, p. 105, figs. 102a–f.

RAPHIA AND THE SYRIAN WARS
W. Huß, *Untersuchungen zur Außenpolitik Ptolemaios' IV.* (Munich 1976).—Pfrommer, *Boscoreale*, pp. 29–31.—B. Beyer-Rotthoff, *Untersuchungen zur Außenpolitik Ptolemaios' III.* (Bonn 1993).—Pfrommer, *Alexandria*, pp. 65–67, 78–92.

RELICS IN PHARAONIC STYLE FROM THE GREAT HARBOR OF ALEXANDRIA
F. Goddio et al., *Alexandrie: Les quartiers royaux submergés* (London 1998).—J.-Y. Empereur, *Alexandria Rediscovered* (New York 1998).

POWERFUL QUEENS: FROM ARSINOË II TO KLEOPATRA VII

WOMEN IN GREEK AND PTOLEMAIC SOCIETY
E. D. Reeder, ed., *Pandora: Women in Classical Greece*, exh., Baltimore (Baltimore 1995).—J. Rowlandson, ed., *Women and Society in Greek and Roman Egypt* (Cambridge 1998).—S. B. Pomeroy, *Women in Hellenistic Egypt: From Alexander to Cleopatra* (New York 1984).

THE MACEDONIAN BACKGROUND OF PTOLEMAIC QUEENS
Grimm, *Alexandria*, pp. 70–81.—Pfrommer, *Alexandria*, pp. 58–61, 81–84, 108–11.

The literature on KLEOPATRA VII is tremendous. See, for example: I. Becher, *Das Bild der Kleopatra in der griechischen und lateinischen Literatur* (Berlin 1966).—M. Grant, *Cleopatra* (New York 1972).—M. Clauss, *Kleopatra* (Munich 1995).—Grimm, *Alexandria*, pp. 126–48.—Pfrommer, *Alexandria*, pp. 135–44.—S. Walker and P. Higgs, eds., *Cleopatra of Egypt: From History to Myth*, exh. (London 2001).

ARSINOË II
S. Albersmeier and M. Minas, in *Egyptian Religion: The Last Thousand Years*, Studies Dedicated to the Memory of Jan Quaegebeur, Orientalia Lovaniensia Analecta, vol. 84 (Louvain 1998), 1: 3–29, pls. 1–2, with bib.—Pfrommer, *Alexandria*, pp. 58–61.

THE DOUBLE CORNUCOPIA
D. Berges, *Rundaltäre aus Kos und Rhodos* (Berlin 1996), pp. 38–41.—Pfrommer, *Studia Varia*.

TYCHE AND THE PTOLEMAIC FAIENCE
D. B. Thompson, *Ptolemaic Oinochoai and Portraits in Faience: Aspects of the Ruler-Cult* (Oxford 1973).

THE TEMPLE OF ARSINOË-APHRODITE ON THE PROMOTORY OF ZEPHYRION
Fraser, *Alexandria*, 1: 239–40.—Pfrommer, *Boscoreale*, pp. 17, 19, 49.

THE ARSINOEION IN ALEXANDRIA
Grimm, *Alexandria*, pp. 76–77.

THE MARRIAGE OF ARSINOË II AND PTOLEMY II
Fraser, *Alexandria*, 1: 117–18.—Grimm, *Alexandria*, p. 70.

THE LOCK OF BERENIKE II
L. Koenen, in *Images and Ideologies: Self-definition in the Hellenistic World*, ed. A. Bulloch et al. (Berkeley 1993),

pp. 89–91.—G. Binder and U. Hamm, in *Candide Iudex: Beiträge zur augusteischen Dichtung*, Festschrift W. Wimmel, ed. A. E. Radke (Stuttgart 1998), pp. 13–34.—W. Kullmann, ibid., pp. 163–79.

THE MOSAIC OF SOPHILOS FROM THMOULS
W. A. Daszewski, *Corpus of Mosaics from Egypt*, vol. 1, *Hellenistic and Early Roman Period*, Aegyptiaca Treverensia, vol. 3 (Mainz 1985), pp. 142–58.—Pfrommer, *Alexandria*, p. 33, fig. 112.

GOLDEN COINS IN THE
NAME OF ARSINOË III
Grimm, *Alexandria*, pp. 106–7, figs. 103c–d.

DEDICATION OF ARSINOË'S LOCKS
AND THE BATTLE OF RAPHIA
Fraser, *Alexandria*, 2: 329, n. 35.

THE DECREE FROM CANOPUS
A. Bernand, *La prose sur pierre dans l'Égypte hellénistique et romaine*, vol. 1, *Textes et traductions* (Paris 1992), pp. 22–35.—W. Huß, *Zeitschrift für Papyrologie und Epigraphik* 88 (1991): 189–208.

RELIGION: ONE LANGUAGE
FOR TWO CIVILIZATIONS

BRONZE COIN OF KLEOPATRA VII
FROM CYPRUS
R. S. Poole, *British Museum, Catalogue of Greek Coins*, vol. 6, *The Ptolemies, Kings of Egypt* (London 1883), pl. 122.2–3.—H. Heinen, *Historia* 18 (1969): 189–90 (47–44 B.C.).—Pfrommer, *Studia Varia*.

THE ALEXANDRIAN WAR OF JULIUS CAESAR
M. Grant, *Cleopatra* (New York 1972), pp. 90–120.

KAISARION (PTOLEMAIOS KAISAR)
H. Heinen, *Rom und Ägypten von 51 bis 47 v. Chr.: Untersuchungen zur Regierungszeit der 7. Kleopatra und des 13. Ptolemäers* (Tübingen 1966).—H. Heinen, *Historia*

18 (1969): 181ff.—Idem, "Eine Darstellung des vergöttlichten Iulius Caesar auf einer ägyptischen Stele," in *Imperium Romanum: Studien zu Geschichte und Rezeption*, Festschrift K. Christ, ed. P. Kneissl and V. Losemann (Stuttgart 1998), pp. 334–45.

PTOLEMAIOS IV AS "NEW DIONYSOS"
AND HIS TRAGEDY TITLED *ADONIS*
Fraser, *Alexandria*, 1: 43–45, 198, 202–5, 311. FOR THE *TECHNITAI* OF DIONYSOS: Fraser, *Alexandria*, 1: 205, 232–33.

THE INSCRIPTION FROM ADULIS
E. R. Bevan, *The House of Ptolemy: A History of Egypt under the Ptolemaic Dynasty* (1968; Chicago 1985), pp. 192–93.—Fraser, *Alexandria*, 1: 203, 208; 2: 344, n. 106.

ALEXANDER AS PREDECESSOR
OF THE PTOLEMIES
E. R. Bevan, *The House of Ptolemy: A History of Egypt under the Ptolemaic Dynasty* (1968; Chicago 1985), pp. 192–93.—Fraser, *Alexandria* 1: 215–19, 224–28.

HAIRNET IN NEW YORK
The Metropolitan Museum of Art 1987.220:
D. Williams and J. Ogden, *Greek Gold: Jewellery of the Classical World*, exh., London (London 1994), p. 254, no. 197, with ill.—Pfrommer, *Alexandria*, p. 11, fig. 5.

AT THE BRINK OF DISASTER:
THE GOLDEN TREASURE
IN ITS HISTORICAL PERSPECTIVE

SNAKE BRACELETS IN GENERAL
Pfrommer, *Goldschmuck*, pp. 126–38.

PTOLEMAIC DYNASTY

305–30 B.C.

(simplified version)

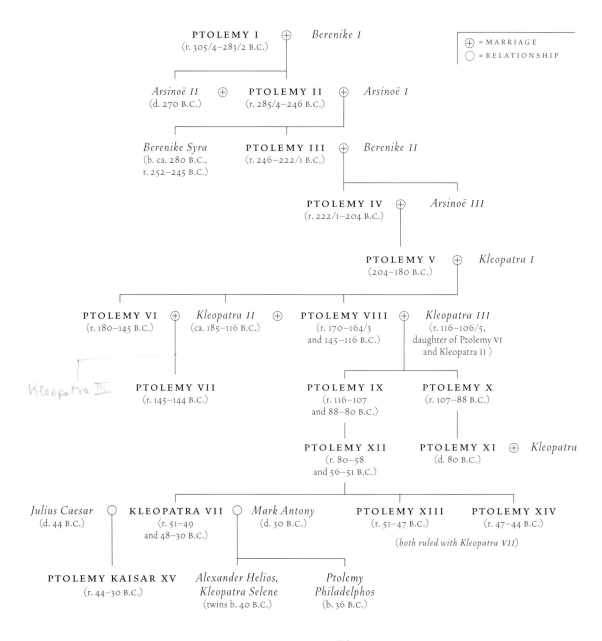

PTOLEMY I (r. 305/4–283/2 B.C.) ⊕ *Berenike I*

⊕ = MARRIAGE
◯ = RELATIONSHIP

Arsinoë II (d. 270 B.C.) ⊕ PTOLEMY II (r. 285/4–246 B.C.) ⊕ *Arsinoë I*

Berenike Syra (b. ca. 280 B.C., r. 252–245 B.C.) — PTOLEMY III (r. 246–222/1 B.C.) ⊕ *Berenike II*

PTOLEMY IV (r. 222/1–204 B.C.) ⊕ *Arsinoë III*

PTOLEMY V (204–180 B.C.) ⊕ *Kleopatra I*

PTOLEMY VI (r. 180–145 B.C.) ⊕ *Kleopatra II* (ca. 185–116 B.C.) ⊕ PTOLEMY VIII (r. 170–164/3 and 145–116 B.C.) ⊕ *Kleopatra III* (r. 116–106/5, daughter of Ptolemy VI and Kleopatra II)

Kleopatra II

PTOLEMY VII (r. 145–144 B.C.)

PTOLEMY IX (r. 116–107 and 88–80 B.C.) — PTOLEMY X (r. 107–88 B.C.)

PTOLEMY XII (r. 80–58 and 56–51 B.C.) — PTOLEMY XI (d. 80 B.C.) ⊕ *Kleopatra*

Julius Caesar (d. 44 B.C.) ◯ KLEOPATRA VII (r. 51–49 and 48–30 B.C.) ◯ *Mark Antony* (d. 30 B.C.) — PTOLEMY XIII (r. 51–47 B.C.) — PTOLEMY XIV (r. 47–44 B.C.)

(both ruled with Kleopatra VII)

PTOLEMY KAISAR XV (r. 44–30 B.C.) — *Alexander Helios, Kleopatra Selene* (twins b. 40 B.C.) — *Ptolemy Philadelphos* (b. 36 B.C.)

ACKNOWLEDGMENTS

A treasure of Hellenistic gold is a spectacular addition to any collection. Liberally sharing this splendor with a foreign scholar is a wonderful example of international cooperation. I can only thank Marion True and the Antiquities Department for all the friendship and generosity that made this study possible.

I am especially indebted to Elana Towne Markus and her unstinting support during my last stay at the Museum. I shall always remember her never-ending patience during all those hours when I tried to dictate the manuscript in my basic English along with German intermissions and apologies for my inability to make myself understood. Day by day I saw another chapter transformed into an English version. I can only guess how frustrating this must have been for a colleague, and I hope that she will be satisfied with the result.

Special thanks go to Benedicte Gilman, Mary Louise Hart, and Louise D. Barber for all their editorial advice and copyediting of the manuscript. This study would not have been possible without their patience and support.

Bernd P. Kammermeier and Panasensor generously provided me with photographs of their model reconstructions of the palace ship of Ptolemy IV and of the tomb of Alexander the Great.

Günter Grimm and the Archaeological Institute of the University of Trier granted me the use of the skills of Ulrike Denis. She transformed my pencil drawings of Ptolemaic Alexandria into colorful illustrations.

For support and hospitality during my numerous visits to the Getty Museum I should like to thank especially John Papadopoulos, Mary Louise Hart, Karol Wight, Marit Jentoft-Nilsen, and all the other members of the staff.

For information and advice I am particularly obliged to Günter Grimm, Heinz Heinen, Victor A. Daszewski, Bärbel Kramer, J. Zeidler, M. Minas, Angelika Paul, Elana Towne Markus, Mary Louise Hart, and G. Platz-Horster.

Ellen Rosenbery's splendid photographs of the jewelry bring out the very best in each of the objects and add color and sparkle to the text.

For permission to illustrate works from their collections I should like to thank the following institutions: Antikensammlungen, Munich; The British Museum, London; The Egyptian Museum, Cairo; Hirmer Fotoarchiv, Munich; Musée du Louvre, Paris; The Metropolitan Museum of Art, New York; and Ny Carlsberg Glyptotek, Copenhagen.

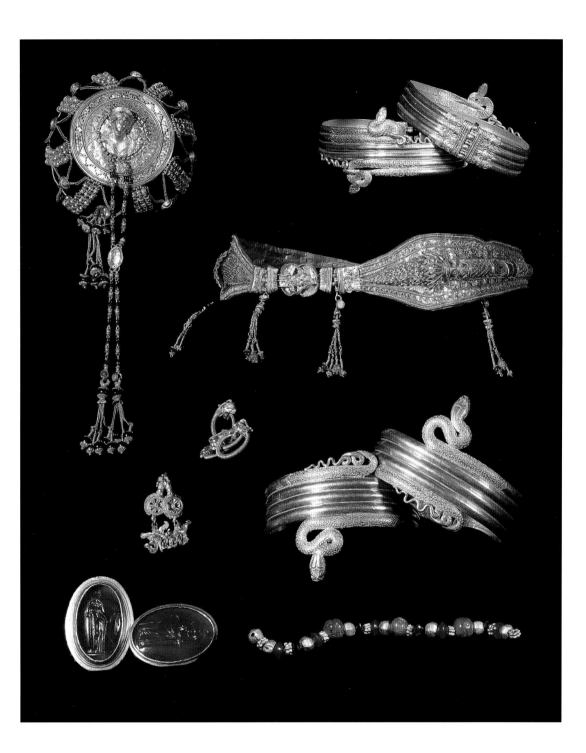